IMAGES
of America

SHIPWRECKS OF
COOS COUNTY

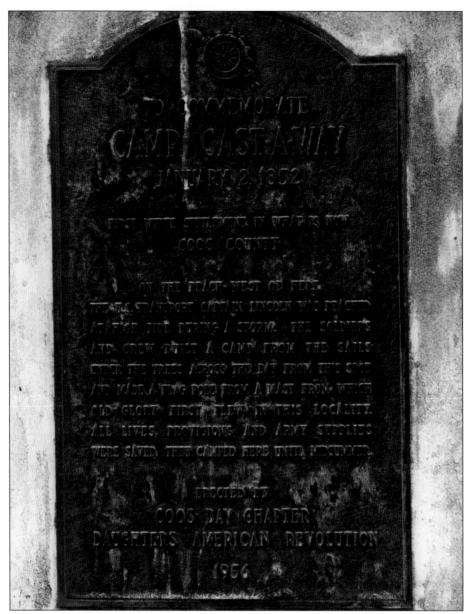

This plaque commemorates Camp Cast-Away, which was the "first white settlement in what is now Coos County." It was built by the survivors of the wreck of the schooner *Captain Lincoln* in 1852. The ship, which was transporting troops to Port Orford, encountered a heavy storm that forced the captain to intentionally beach the leaking vessel. The men built a temporary camp out of sails from the ship on what is now known as the North Spit of the Coos Bay. (Coos Historical and Maritime Museum 981-172b.)

ON THE COVER: On November 2, 1915, the steamer *Santa Clara* struck a sandbar south of the entrance to the Coos Bay. Ironically, most of the survivors chose to remain on the sinking vessel rather than attempting to take a lifeboat to shore in the rough surf. In this photograph, several people are attempting to board the wreck. (Coos Historical and Maritime Museum 992-8-2851.)

IMAGES
of America

SHIPWRECKS OF
COOS COUNTY

H. S. Contino

ARCADIA
PUBLISHING

Published by Arcadia Publishing
Charleston, South Carolina

Printed in the United States of America

Library of Congress Control Number: 2010928312

For all general information, please contact Arcadia Publishing:
Telephone 843-853-2070
Fax 843-853-0044
E-mail sales@arcadiapublishing.com
For customer service and orders:
Toll-Free 1-888-313-2665

Visit us on the Internet at www.arcadiapublishing.com

*For anyone who has ever looked out to sea and
wondered about the possibilities.*

CONTENTS

Acknowledgments 6

Introduction 7

1. The Coos Bay Bar 9

2. Coos Bay's North Spit 19

3. The Coos Bay Jetties 39

4. The Coos Bay 53

5. The Coquille River Bar 67

6. The Coquille River Jetties 77

7. Coastal Wrecks 93

ACKNOWLEDGMENTS

This project would not have been possible without the encouragement of my family and friends. I would especially like to thank Vikki McLain, Karen Lind, June Contino, and Diana Esposito for their unwavering support throughout the writing process.

I am grateful to the staff at the Coos Historical and Maritime Museum (CHMM) for allowing me access to their archives. I would like to thank collections manager Vicki Wiese for allowing me to use the museum's photographs in this book.

Although we never met, I would like to acknowledge the late Victor West, local maritime historian. His research binders have been invaluable to the completion of this project.

Finally, I would like to thank Arcadia Publishing for allowing me the opportunity to research and write about a topic that has fascinated me for years.

INTRODUCTION

Although early explorers visited the area, European settlement of what is now known as Coos County essentially began with a shipwreck. The *Captain Lincoln,* a wooden-hulled U.S. transport schooner, departed from Benecia, California, in December 1851 with a contingent of soldiers and a cargo of military supplies for Port Orford, Oregon. The ship encountered a heavy storm in January 1852 that caused it to miss its destination and head too far north. The captain, who feared the leaking vessel would not survive the storm, intentionally beached the ship in order to save the lives of the men on board. They built a temporary camp out of sails from the ship on what is now known as the North Spit of the Coos Bay and named it Camp Cast-Away. They lived in the camp and traded with local Native American tribes for several months before they made the overland journey to Port Orford. Upon their arrival, they told other settlers about the Coos Bay and its many natural resources. Some of these settlers, miners, and merchants chose to visit the area for themselves. By December 1853, Coos County had been established by the territorial legislature, several towns had been established, and the first sawmill in the county was in operation. Therefore, the history of the area was completely altered by a single shipwreck.

The Oregon coast is treacherous and difficult to navigate. Through the years, several hundred vessels have been lost along the coastline and around the many rivers. Coos County has two main harbors—Coos Bay and Bandon. Both were troublesome for early mariners who were often faced with heavy seas, hidden reefs, violent storms, and varying water depths. In addition, many ships lost their bearing and strayed too close to shore where they either grounded or were forced onto rocky cliffs by strong winds and heavy currents. Early Coos County was isolated, and the lack of roads made the area difficult to access. Prior to 1916, there was not a passenger railroad service. The majority of people and freight were forced to travel to and from Coos County by ship, thus the loss of life and cargo due to shipwrecks was enormous.

Over the years, numerous improvements have been made in order to reduce the dangers. Around 1900, early settlers began planting Holland grass on the dunes in order to reduce the movement of the sand. On both rivers, stone jetties were built that extend out from their entrances in order to provide a safe channel for ships to travel. In addition, the waterways are frequently dredged in order to maintain the channel depth. All of these efforts combine to make the ports of Coos Bay and Bandon safer and much more reliable, but accidents still occur.

The causes of shipwrecks vary greatly. Fire, collision, grounding, operator error, equipment malfunction, and foul weather have claimed numerous vessels. Fog, in particular, can be a major problem on the Pacific Coast. For instance, the *Sujameco* grounded near Coos Bay in a thick fog in 1929. The sea itself is often the cause of trouble. It can be rough and full of breakers and crosscurrents that make it difficult for ships to cross the river bars on their way to and from the open sea.

It is important to note that like automobile accidents, not all shipwrecks are total losses. The term *shipwreck* can encompass everything from the equivalent of an automobile fender bender

up to the total loss of the ship, its cargo, and the passengers and crew. In many cases, ships were repaired and returned to service where they continued to operate for many years following their accidents. For instance, after the fire that gutted the *Congress* in 1916, the passenger liner was rebuilt. The vessel remained in service for another 30 years.

Shipwrecks have always drawn spectators; but why? What is it that draws people to them? Is it the unfolding drama? Perhaps it is the reminder of the awesome power of the sea and man's feeble attempts to control it. The reminder is that there is no such thing as an "unsinkable ship"—there is nothing that man can build that the ocean cannot claim. Do the people come to offer their assistance in rescuing the passengers and crew? Or are the wrecks simply a form of entertainment? Perhaps visitors are motivated by the thought of treasure and come to see what they can scavenge from the wreckage.

Historically, shipwrecks have simultaneously brought out both the best and the worst in people. The following pages contain the stories of shipwrecks, but they also contain the stories of the people involved—passengers, crews, and spectators. They are stories about both the heroes and the villains. For instance, after the collision of the dredge *William T. Rossell* and the freighter *Thorshall*, helicopter pilot Wesley Lematta made numerous trips between the nearly submerged dredge and the shore while rescuing the crewmen one at a time. However, during other wrecks there have been reports of mass looting from the general public. The worst example of this behavior occurred after the wreck of the *Santa Clara*, which is featured on the cover of this book. When the hull of the *George L. Olson* was uncovered by storms on the sand dunes of the North Spit in 2008, it was necessary to patrol the area in order to prevent visitors to the wreck site from attempting to remove parts of the ship as souvenirs.

This book does not cover *all* of the wrecks that have occurred in Coos County, Oregon. There are simply too many to address them all. It does, however, include a variety of vessel types that range from small fishing boats to large freighters and old wooden sailing schooners to steel-hulled steamships. From the *Captain Lincoln* in 1852 to the *New Carissa* in 1999, this book provides a photographic overview of several of the most exciting, fascinating, tragic, and visually stunning shipwrecks in Coos County's history.

The chapters have been organized based upon the locations where the wrecks occurred. Essentially, the book has been divided into two unofficial sections. The first discusses the frequent wreck locations near the port of Coos Bay, which include the Coos Bay bar, Coos Bay's North Spit, the Coos Bay jetties, and wrecks on the Coos Bay itself. The second section discusses wreck locations near the Port of Bandon and covers the Coquille River bar and the Coquille River jetties. The final chapter discusses shipwrecks along the Coos County coastline.

One

THE COOS BAY BAR

The Coos Bay bar is located at the mouth of the Coos River. For those unfamiliar with the term, nautically speaking, the word *bar* refers to the silt that accumulates near the shallow entrance to rivers. The combination of shallow water and sand accumulation can equal disaster for ships attempting to travel to or from the open sea. During unfavorable weather conditions, a river bar can become so dangerous that it can prevent a ship from accessing a river or harbor altogether.

Over the years, the Coos Bay bar has been the location of at least 60 shipwrecks. The earliest wrecks were caused by a variety of problems: the shifting channel, the lack of pilot boats to guide the ships, the failure of the wind while sailing vessels were crossing, and the lack of lights and markers to guide the vessels into a safe channel. Historically the sand dunes to the north were particularly troublesome. During windy weather, the sand was often carried onto the bar, which decreased the depth of the water.

Many improvements have been made to the Coos Bay bar over the years. In the early 1900s, Coos County settlers began planting Holland grass and other vegetation on the dunes in order to reduce the movement of the sand. The Coos Bay was dredged in order to create a shipping channel that guaranteed a minimal water depth. It has since been widened and deepened to accommodate larger ships carrying heavier loads of cargo. As of 2010, the overall depth of the channel was 37 feet. However, continuous dredging is necessary. In addition, two jetties were constructed to protect the harbor entrance and help maintain the channel depth. The combined result of these improvements has made the Coos Bay bar safer, but it has not eliminated the danger altogether.

On September 12, 1971, three boats capsized on the Coos Bay bar. It all began when a 14-foot fiberglass boat with four people on board overturned near the south jetty. Then, three men in a small wooden boat capsized while attempting to assist them. Finally, a 25-foot Coast Guard vessel arrived on the scene, but it capsized while the crewmen were attempting to hoist someone aboard. At this point, there were nine people struggling in the rough surf. The two coastguardsmen were lucky. They managed to cling to their overturned vessel before swimming to the jetty. The water was full of floating debris after the three boats smashed against the jetty rocks. (Above, CHMM 009-16.1294; below, CHMM 995-1.53495.6.)

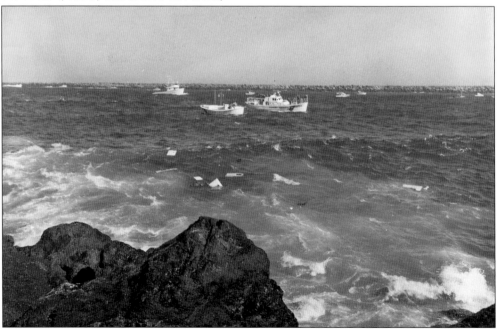

A local newspaper reported several boats and a Coast Guard helicopter arrived at the accident scene within five minutes. Unfortunately, they were not fast enough. Of the nine people who went into the water, two were rescued and another two managed to climb onto the south jetty; sadly, the other five drowned. None were wearing a life jacket. In the photograph on the right, a crowd has gathered on the jetty while boats and the helicopter continue to patrol the water looking for victims. Pieces of the three capsized vessels have drifted onto the south jetty, and other sections are floating in the water nearby. The image below shows the extensive damage to the Coast Guard boat. (Right, CHMM 995-1.53495.8; below, CHMM 995-1.53503.1.)

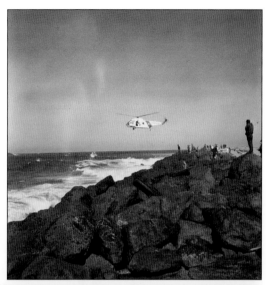

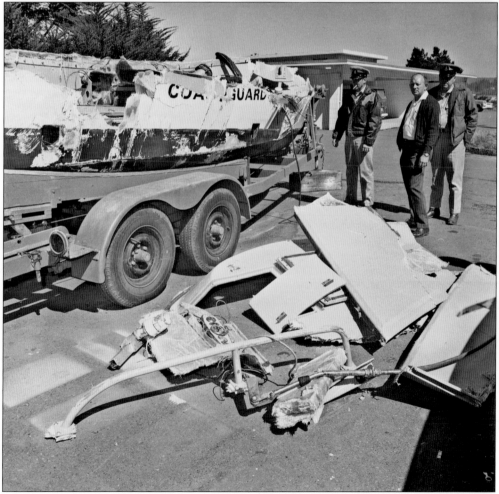

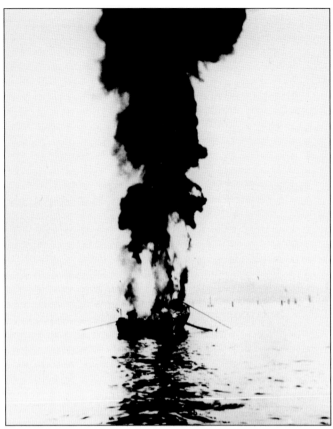

On September 23, 1949, the fish boat *Judy Jane* caught on fire while crossing the Coos Bay bar. The 38-foot boat was built in Toledo, Oregon, in 1940. After failing to extinguish the fire, the pilot jumped overboard and was rescued by another boat, the *Surf*. In this photograph, the *Judy Jane* is fully engulfed by flames. (CHMM 007-25.234.)

The *Judy Jane*'s fuel tanks contained 400 gallons of gasoline that could explode. After failing to extinguish the fire, the Coast Guard towed the burning vessel onto the Joe Ney Slough in order to reduce the danger to other ships. The photograph below shows the severe damage to the boat after the fire burned itself out. (CHMM 009-16.944.)

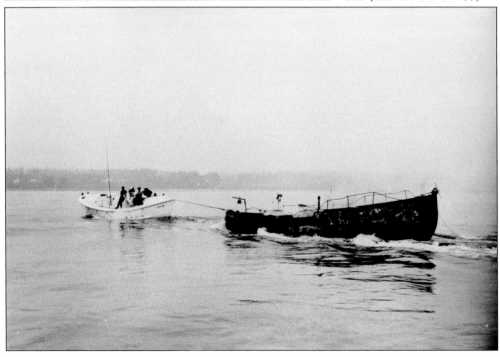

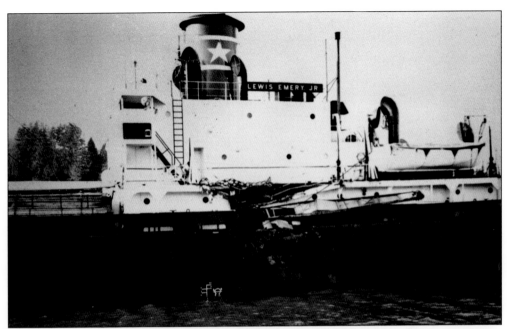

Poor visibility was blamed for the collision of the two steamers *George S. Long* and *Lewis Emery Jr.* on January 24, 1955. The ships were traveling just outside of the Coos Bay bar in a thick fog. Although both vessels were damaged, they both returned to the Coos Bay port without assistance. The *Lewis Emery Jr.*, shown above, sustained a large hole on its port side. The photograph below is a close-up view of the damage. The *George S. Long* had a three-foot hole in its bow. Both vessels were temporarily repaired and returned to service. Fortunately, there were no casualties as a result of the accident. (Above, CHMM 009-16.412; below, CHMM 009-16.412a.)

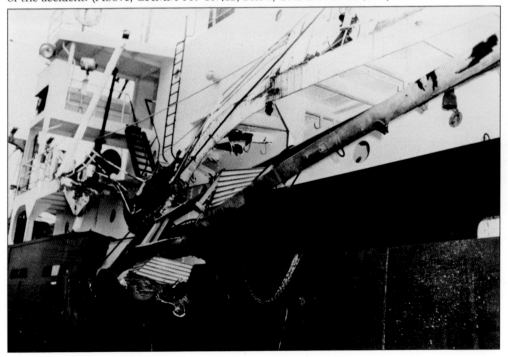

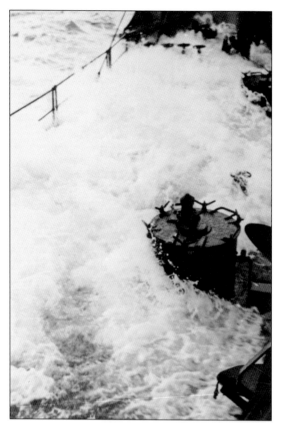

The Canadian motor tanker *Petrolite* narrowly escaped disaster on March 23, 1945. While crossing the Coos Bay bar in rough conditions, the ship was struck by several huge breakers that washed completely over it and drowned out its one running engine. The waves continued to beat against the helpless vessel and managed to completely turn it around. Fortunately, the crew was able to start the second engine and regain control of the ship. The *Petrolite* returned safely to port and suffered only minor damage in the incident. At left, a large wave completely submerges the deck. Part of a railing is visible, but most of the other features of the vessel are obscured by the waves. The photograph below was taken from the bridge. (Left, CHMM 007-25.227; below, CHMM 007-25.238.)

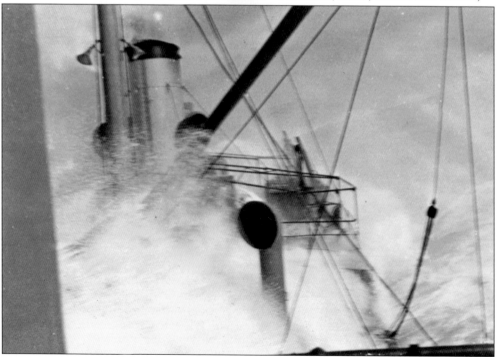

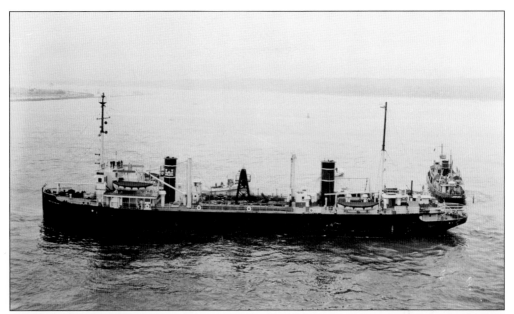

On September 10, 1957, the Norwegian freighter *Thorshall* swerved off course and collided with the U. S. Army dredge *William T. Rossell* on the Coos Bay bar. Although both ships were damaged, the dredge suffered the worst of it. It sank within five minutes, taking three of its 49 crewmen with it. A fourth crewman died of a heart attack shortly after being rescued. (CHMM 009-16.1000.)

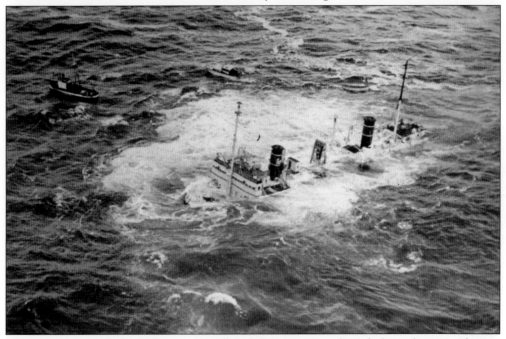

The *Thorshall* struck the *William T. Rossell* mid-ship, creating a large hole in the port side near the engine room. The dredge was divided into three watertight compartments. However, it was struck at the compartment separator which caused two of them to immediately flood. The wreck was surrounded by sea foam as breakers continued to wash over the nearly submerged ship. Several small boats circled nearby looking for survivors. (CHMM 007-25.463.)

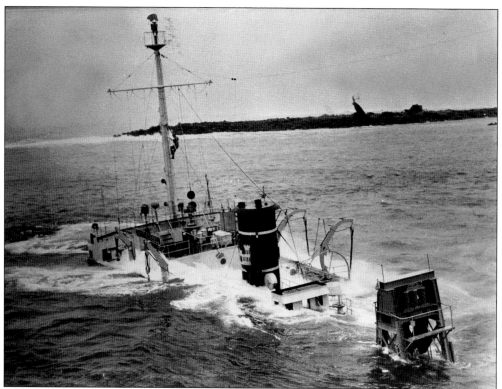

The small portion of the *William T. Rossell* that remained above the waterline provided the only refuge for the surviving crewmen. The Coos Bay bar was extremely choppy that day, which made it difficult for the survivors to cling to the ship without getting washed away. Above, a man is clinging to the mast. The ship's nameplate and the U.S. Army Corps of Engineers emblem are clearly visible. (CHMM 992-8-2843.)

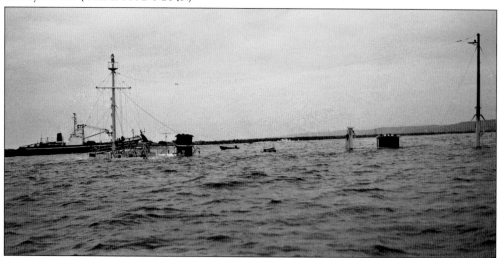

Although the 3,490-ton dredge *William T. Rossell* became a total loss, the accident was a good example of a disaster bringing out the best in people. Many captains of local boats assisted in the retrieval of the crew. The Red Cross, Coast Guard, and numerous local businesses offered food, clothing, and housing to the survivors. (CHMM 009-16.369i.)

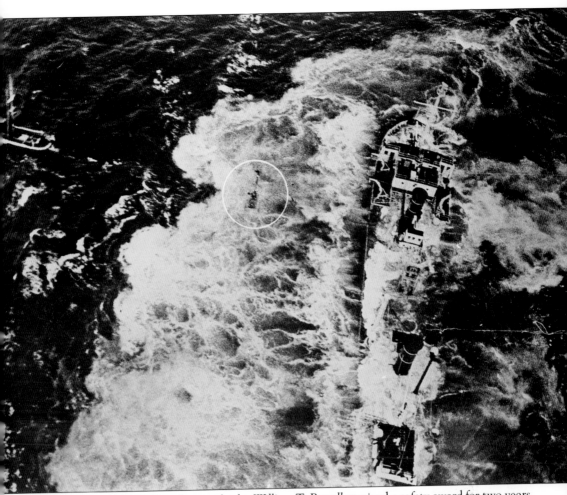

Ironically, six hours before the wreck, the *William T. Rossell* received a safety award for two years of service without any accidents. Col. Jackson Graham, commander of the U.S. Army Corps of Engineers Portland District, chartered a helicopter for the day. He flew to Coos Bay to present the award. He was later quoted in *The World* newspaper: "It was the kiss of death." The presence of the helicopter was, however, incredibly fortunate. The pilot, Wesley Lematta, was a hero. Unlike the boats on the water, his tiny two-seater could dart in and out of the breakers in order to reach the survivors clinging to the ship. He made numerous trips, lowering a line to the crewmen, lifting them away from the wreck, and then depositing them safely onto the north jetty. Many witnesses said he appeared to be "lassoing" the survivors, and they praised his heroic determination. Lematta succeeded in saving 15 men. In this photograph, his tiny helicopter has been circled. It is barely visible in the rough surf. (CHMM 992-8-2842.)

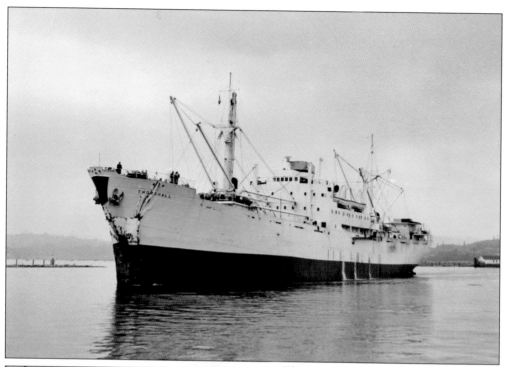

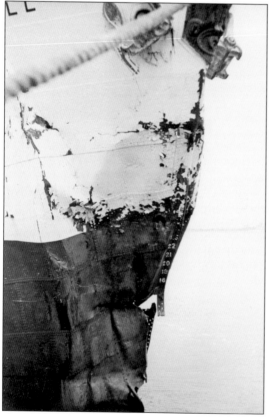

The Norwegian motor vessel *Thorshall* was criticized after the collision with the *William T. Rossell* on September 10, 1957. The Coast Guard's Marine Board of Investigation, however, determined that the master of the *Thorshall* "acted within a reasonable manner to avoid the collision" and that "in the absence of the mechanical failure on the *Thorshall*, the vessels would have passed uneventfully." In these photographs, the extensive damage to the *Thorshall* is apparent. The above image is an overall view while the photograph at left is a close-up of the damage to the bow. The *Thorshall* was temporarily repaired at Coos Bay, Oregon, before proceeding to Seattle, Washington, where a new bow was installed. The *William T. Rossell* was too badly damaged to be refloated. Explosives were used to destroy the hull since it posed a potential hazard to other vessels. (Above, CHMM 007-25.461; left, CHMM 009-16.370.)

Two

COOS BAY'S NORTH SPIT

The land to the north of the entrance to the Coos Bay is referred to as the North Spit. It consists of a long narrow strip of sand dunes. It is also the beginning of the Oregon Dunes National Recreation Area, which was established by Congress in 1972 and extends northward for 38 miles along the coastline. Early settlers planted Holland grass and other deep-rooted vegetation in order to prevent the sand from drifting onto the river bar and affecting the depth of the shipping channel. This has drastically changed the appearance of the North Spit. The area that was once nearly treeless is now covered with grass and trees. An estimated 500 acres are now covered with vegetation.

The North Spit has been the location of a large number of maritime accidents for two main reasons. First, many ships encounter problems while crossing the Coos Bay bar and become disabled. These vessels are often driven northward by strong currents until they are deposited on the North Spit where they either run ground or are torn apart in the breakers. Second, the spit is deceptive. It is easy for vessels to stray into shallow water and strand.

The ocean currents deposit flotsam and jetsam on the North Spit every year. The items that are not picked up by beach combers are eventually buried in the sand. The area is also the final resting place of numerous shipwrecks. Winters on the Oregon coast can be exciting because the storms, strong currents, and heavy winds can uncover treasures that have been buried in the dunes.

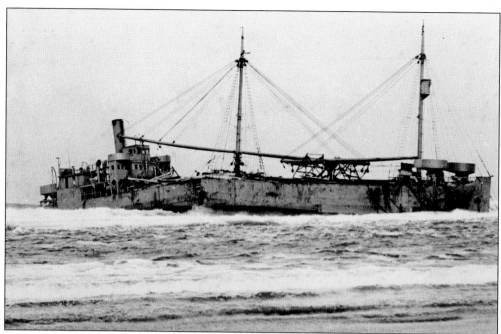

The steam schooner *Alvarado* was built at Long Beach, California, in 1914. On March 17, 1945, the ship encountered a storm that first disabled it and then forced it into the surf on the North Spit 6 miles north of the Coos Bay. The storm was so severe that it took the Coast Guard several attempts to rescue the 31 crewmen. The *Alvarado* drifted onto the beach where a large vertical crack began forming in its steel hull, and the pounding surf soon broke the ship into two pieces. Gale force winds scattered its cargo of lumber for miles along the shoreline. (Above, CHMM 009-16.365; below, CHMM 009-16.917a.)

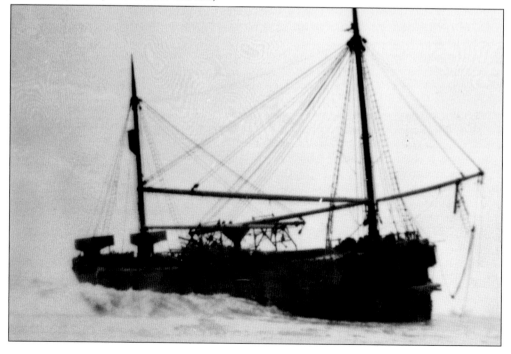

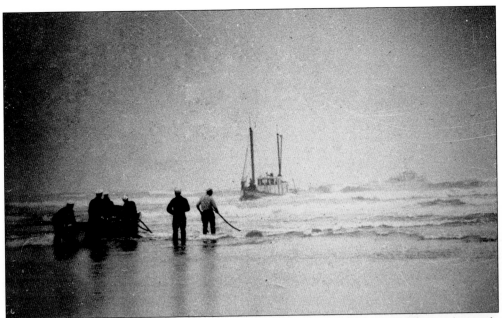

On August 8, 1935, the *C. R. P. A. No. 2* stranded on the North Spit approximately 1 mile north of the Coos Bay bar. The small cannery tender, owned by the Columbia River Packer's Association, encountered thick fog while traveling from Astoria to North Bend. Its cargo was thrown overboard in order to reduce the weight, and 65 empty oil drums were placed in the holds for buoyancy. On August 10, the tugs *Pilot*, *Umpqua Chief*, and *Coos Bay* with the assistance of the U. S. Coast Guard Cutter *Pulaski* succeeded in pulling the *C. R. P. A. No. 2* off the beach. It was refloated and towed onto the Coos Bay for repairs. (Above, CHMM 009-16.1310a; below, CHMM 009-16.1310b.)

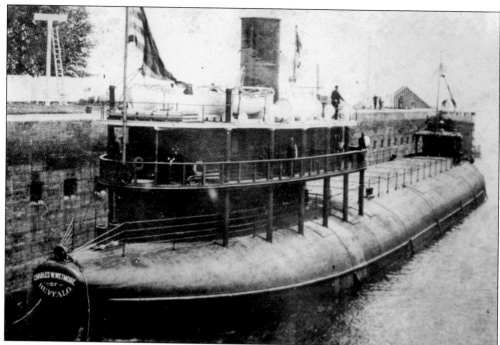

The *Charles W. Wetmore* was an example of an unusual hull design known as a "whaleback." The hull was designed by Capt. Alexander McDougall, who wanted a ship that would create less water resistance, have increased cargo capacity, and have less risk of capsizing in rough seas. The result was a cigar-shaped vessel that had a steel hull with rounded sides and a flat bottom. It had a small cabin and pilot house that perched on top and were connected by catwalks. Fully loaded, the majority of the hull was submerged, which is how it received the nickname whaleback. At sea, the ships resembled whales riding on to the surface of the waves. The *Charles W. Wetmore* was named after one of McDougall's financial supporters, but the name was unfortunate. Other mariners often quipped that the ship was "wet more" than it was dry. (Above, CHMM 007-25.63; below, CHMM 992-8-3042.)

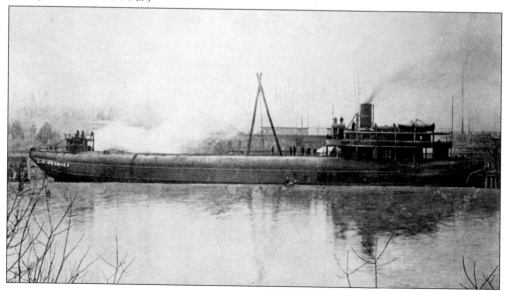

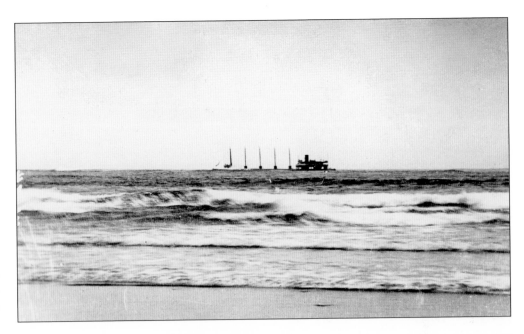

The *Charles W. Wetmore* was the first whaleback to operate outside of the Great Lakes. Its unusual hull design drew attention wherever it traveled. When it visited England in 1891, it was the first whaleback to make such a long journey. On September 8, 1892, the *Charles W. Wetmore* stranded a mile north of the Coos Bay bar in a thick fog while under the command of Capt. Johnny "Dynamite" O'Brien. It was traveling from Tacoma, Washington, to San Francisco, California, with a cargo of coal. No lives were lost, but the *Charles W. Wetmore* became a total loss. The above photograph was taken while standing on the North Spit and looking out to sea. The decorative gold leaf came from the wreck. (Above, CHMM 009-16.328; below, CHMM 010-1.27.)

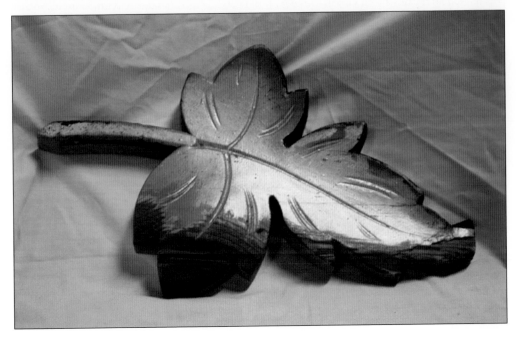

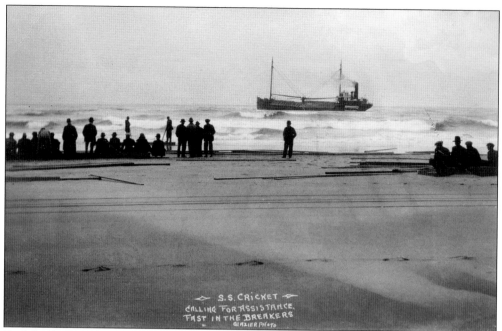

S. S. CRICKET
CALLING FOR ASSISTANCE.
FAST IN THE BREAKERS
GLAZIER PHOTO

On July 12, 1914, the steam schooner *Cricket* strayed too close to shore and stranded 4 miles north of the Coos Bay. The ship, under the command of Capt. John Wehman, was transporting lumber from Port Angeles to San Pedro when fog caused it to stray off course. The *Cricket* was fortunate. It was one of the few larger vessels that grounded on the North Spit but was successfully refloated. The deck cargo was jettisoned in order to reduce its weight. The steam schooner *Bee*, the gas schooner *Rustler*, and the U. S. Army Corps of Engineers dredge *Col. P. S. Michie* worked together to pull the *Cricket* off the beach. (Above, CHMM 982-190.70; below, CHMM 007-25.31.)

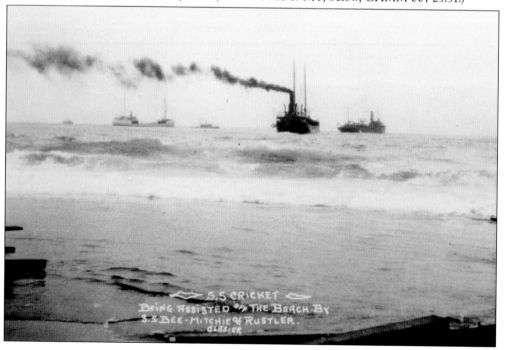

S.S CRICKET
BEING ASSISTED OF THE BEACH BY
S.S BEE · MITCHIE & RUSTLER.
GLAZIER

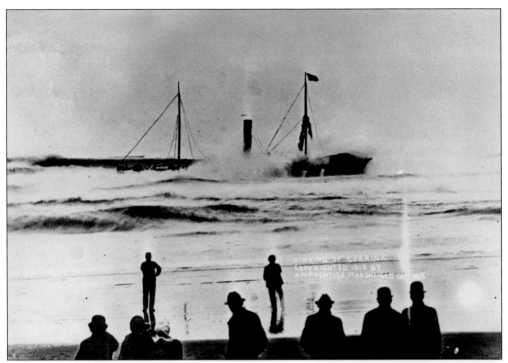

The iron-hulled *Czarina* was built in Sunderland, England, in 1883. While crossing the Coos Bay bar on January 12, 1910, the 1,045-ton steamship was struck by a succession of waves that flooded the engine room, dousing the coal fires. It drifted northward until Capt. Charles Dugan ordered his crew to drop anchor. This caused the vessel to ground on the beach where it was exposed to heavy breakers. Several boats responded to the *Czarina*'s distress call, but they were unable to reach the ship. The deck load of lumber broke loose, and the lifeboats were either washed away or destroyed by floating debris. The crew and the one passenger took refuge in the rigging where they clung for hours before dropping one by one to their deaths. Only one crew member survived. (Above, CHMM 007-25.540; right, CHMM 008-16.1.)

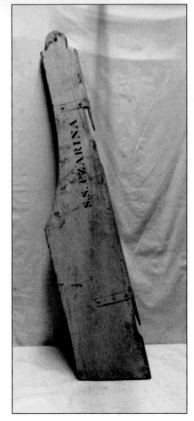

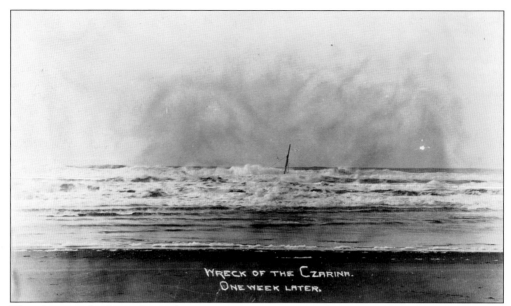

WRECK OF THE CZARINA.
ONE WEEK LATER.

The photograph above shows the steamer *Czarina* one week after its became a total loss on the North Spit. The shipwreck is considered one of the most tragic and controversial in Coos County history. The crew of the life-saving station received a large amount of criticism. After an investigation, two crewmen were charged and suspended for plundering objects that drifted ashore from the wreck. In addition, Keeper Boice was found guilty on six charges of negligence and demoted. The photograph below is of a piece of the ship's wheel, which washed ashore during the shipwreck. (Above, CHMM 006-27.16; below, CHMM 010-1.18.)

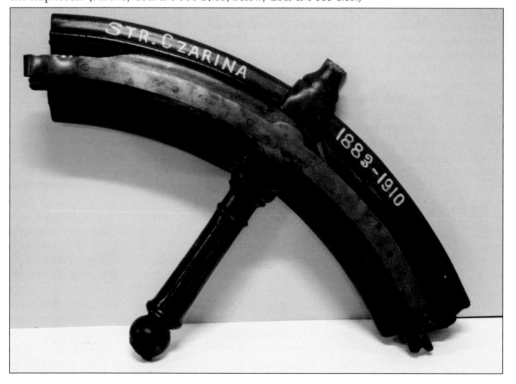

The 120–gross ton *Helen E.* began its career as the U.S. Naval subchaser *SC-1316*, which was constructed at Nyack, New York, in 1943. After the war, the ship was converted into a fishing boat and renamed. On March 5, 1951, the *Helen E.* grounded on the North Spit approximately 4 miles north of the Coos Bay during a storm. Although several salvage attempts were made, they all failed. The ship was eventually stripped of all of its valuables and abandoned. Its hull was burned for scrap. (Right, CHMM 995-1.13094.6; below, CHMM 995-1.13831.1.)

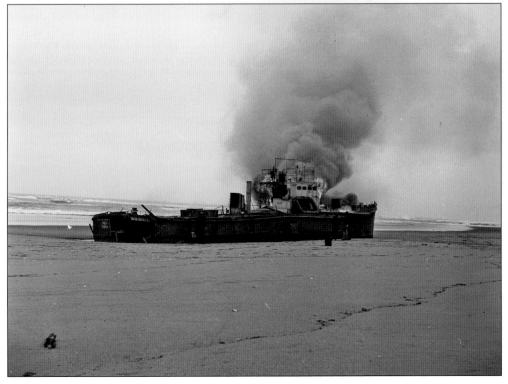

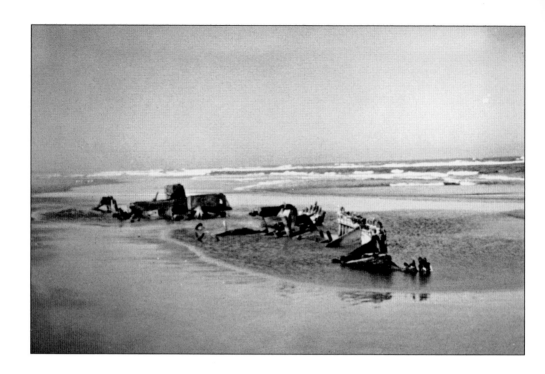

Although the fishing boat *Helen E.* was burned after it grounded on the North Spit in March 1951, a portion of its hull survived. It is usually buried in the sand. But the remains of the boat can occasionally be seen at low tide. This usually occurs after the area has received a storm with strong winds and heavy currents that are strong enough to expose the wreck. The first photograph was taken shortly after the *Helen E.* was burned. The second photograph was taken in the spring of 2010. It is interesting to compare how much the ship has deteriorated during the years in between. (Above, CHMM 009-16.922; below, CHMM 010-4.3.)

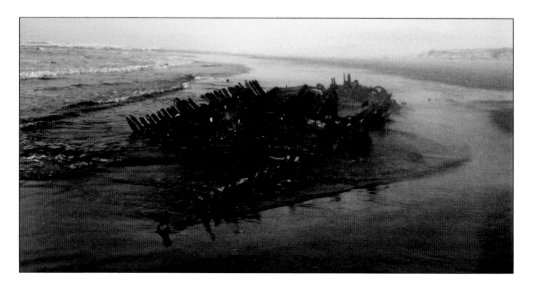

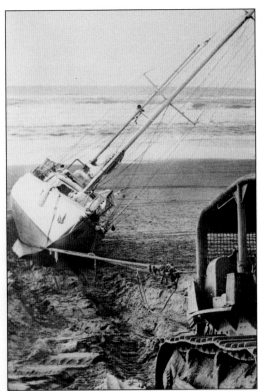

On February 12, 1972, the 45-foot pleasure sailboat *Inisfail* missed the channel while attempting to enter the Coos Bay. The sailboat was carried north by the currents until it beached on the North Spit approximately 4 miles north of the bar. All five of its passengers escaped without injury. However, due to the isolated location, recovering the boat posed a problem. In the end, the *Inisfail* was towed across the sand dunes. It was then taken to Hillstrom Shipbuilding Company to be repaired. (Right, CHMM 009-16.1588; below, CHMM 009-16.1588a.)

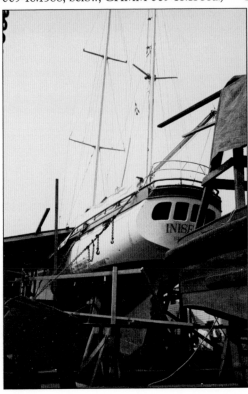

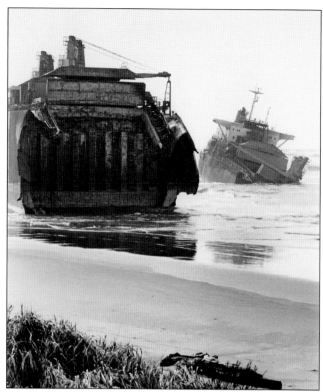

On February 4, 1999, the *New Carissa* ran aground on the North Spit of the Coos Bay. As its story unfolded on the national news, the 639-foot freighter became a tourist attraction. Every attempt to pull the *New Carissa* off the beach failed. An estimated 70,000 gallons of fuel leaked out into the sea, where it congealed into balls of tar. Due to the currents and wave action, the oil contaminated a very large area and killed hundreds of shorebirds. On February 10, the remaining fuel was set on fire. Although 190,000 gallons of fuel were destroyed, the blaze also caused the vessel to split into two pieces. (Left, CHMM 008-82.4; below, CHMM 008-82.5.)

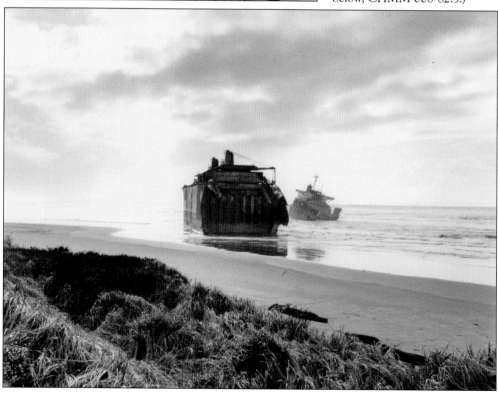

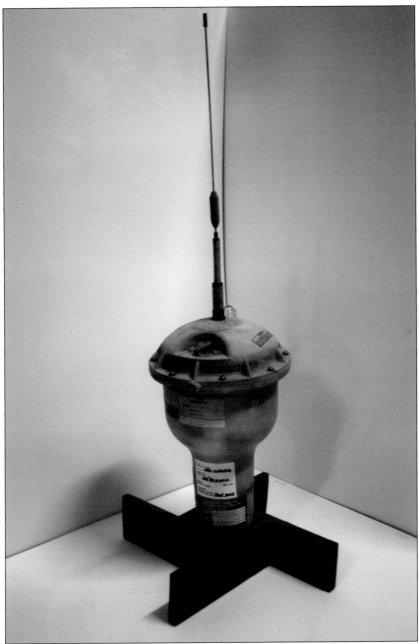

This Emergency Position Indicator Radio Beacon was recovered from the *New Carissa*. On February 26, the *Sea Victory* succeeded in pulling the bow section off the beach and slowly began to pull it out to sea. On March 2, two of the towlines snapped during a winter storm. The *New Carissa's* bow drifted 80 miles northward before running aground near Waldport where 2,000 additional gallons of oil leaked and caused ecological problems. By now, there was a great deal of cynical humor associated with the wreck. A local company printed T-shirts with the phrase "Coming to a Beach Near You." Another company sold coffee mugs commemorating the "New Carissa Oregon Coast Beach Tour." The mugs included the dates and locations of the ship's groundings. (CHMM 002-7.172.)

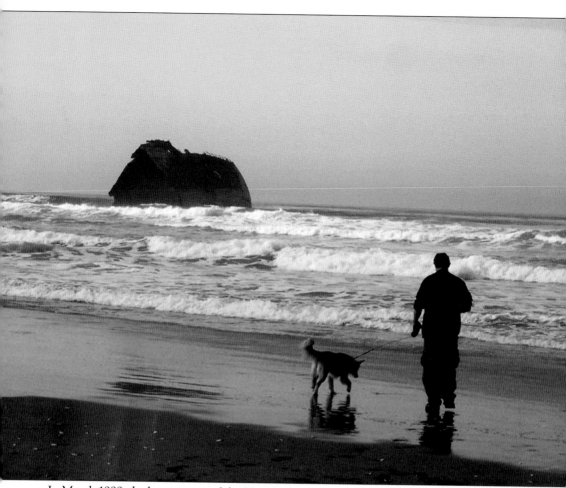

In March 1999, the bow section of the *New Carissa* was towed to sea and sunk by navy torpedoes in 10,000 feet of water. Salvage crews then focused their efforts on the stern section. By July, they removed the majority of the wreck's ecological hazards, but they left the stern section on the beach where it continued to draw tourists to the area. The photograph above was taken in 2007. The 200-foot stern section of the *New Carissa* remained on the North Spit of the Coos Bay until 2008. A court ruled that the ship was "trespassing in state waters" and must be removed. Titan, a marine salvage and shipwreck company, was hired to remove the wreckage. (Author's collection.)

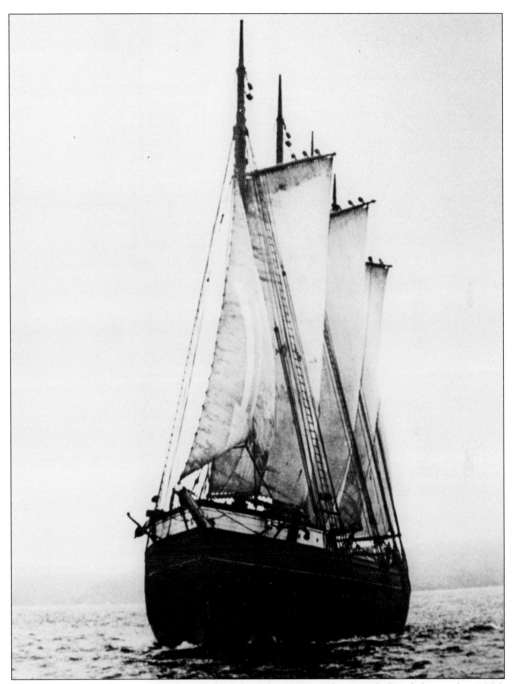

The four-masted schooner *Novelty* was built by John Kruse at his North Bend shipyard in 1886. The ship, which was built for A. M. Simpson, was 592 gross tons and capable of carrying up to 800,000 feet of lumber. The *Novelty*'s name referred to its rigging. It was a "bald-headed" schooner, which simply means that it had no topmasts or topsails. The ship was also launched without a bowsprit. The *Novelty* was so unusual that an article in the *Coos Bay News* claimed that it should have been named the "*Oddity*." The *Novelty* was also the first four-masted schooner to be built on the Pacific coast. (CHMM 009-16.15.)

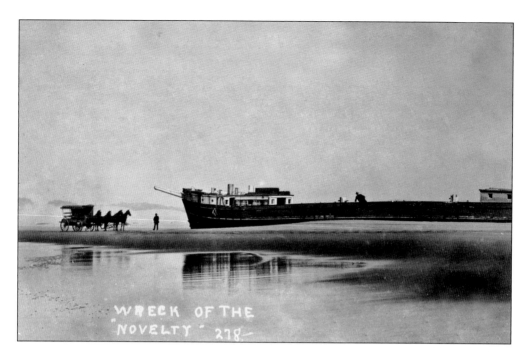

WRECK OF THE
"NOVELTY" 278

On October 23, 1907, the *Novelty* ran aground just north of Ten Mile Creek (several miles north of the Coos Bay). Fog was blamed for the accident. The *Novelty* was stripped of all valuable gear and abandoned. At the time, there were few roads in the area. The *Novelty*'s beach location and intact condition made it a popular rest stop on the Marshfield-Drain stage line, which ran along the beach at low tide. In these photographs, several people are exploring the wreck while the driver and his team of horses wait patiently. (Above, CHMM 992-8-0023; below, CHMM 009-16.334.)

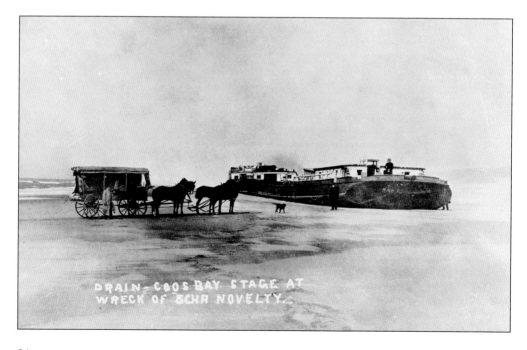

DRAIN-COOS BAY STAGE AT
WRECK OF SCHR NOVELTY.

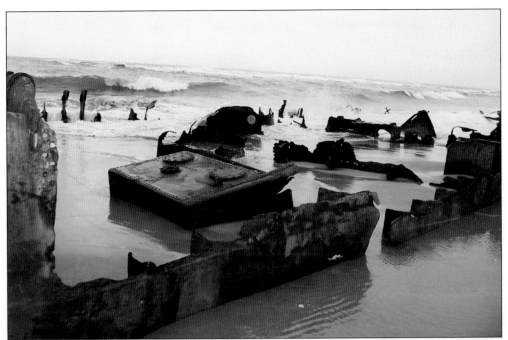

The remains of the shipwreck of the *Sujameco* are a frequent attraction on the North Spit of the Coos Bay. The steel-hulled *Sujameco* was built in Newark, New Jersey, in 1920 by the Submarine Boat Corporation. All of the vessels owned by the company had names that began with the letters *su* and ended in *o*. For instance, the *Sujameco's* sister ships were *Sulanierco* and *Sugillenco*. (Author's collection.)

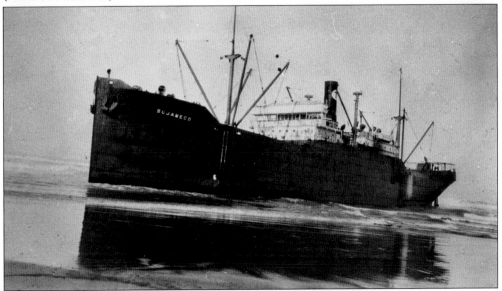

On March 1, 1929, the *Sujameco* grounded on the North Spit. There are two versions of the story. The first claims the ship hit the beach bow first. The vessel remained in this position for several hours before strong waves turned it sideways. The second claims the vessel missed the entrance to the Coos Bay, turned around, and was engulfed in thick fog, which caused it to run aground. (CHMM 992-8-2880.)

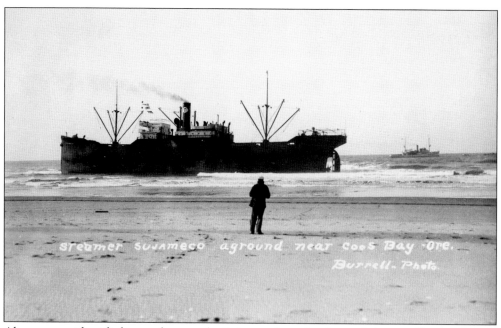

Steamer Sujameco aground near Coos Bay -Ore.
Burrell-Photo.

Above, an unidentified man observes the *Sujameco* from the shore while a smaller vessel waits offshore to render assistance. Although smoke stills billows from the steamship's smokestack, it is already becoming a tourist attraction. Thousands of people traveled to the North Spit to see the grounded ship. Meanwhile, the crew, who continued to live on board, became homesick. A local Boy Scout troop brought them newspapers and treats to cheer them up. Several attempts were made to free the vessel, but it refused to budge. The *Sujameco* was eventually stripped of anything valuable and abandoned. The federal inspection service investigated the shipwreck. It determined that the accident could have been avoided if Captain Carlson had taken soundings and reduced his speed. He was also disoriented. When the distress signal was sent, he claimed his ship was located 50 miles north of Cape Arago. Carlson's license was suspended. (Above, CHMM 009-16.357; below, CHMM 995-23.143a.)

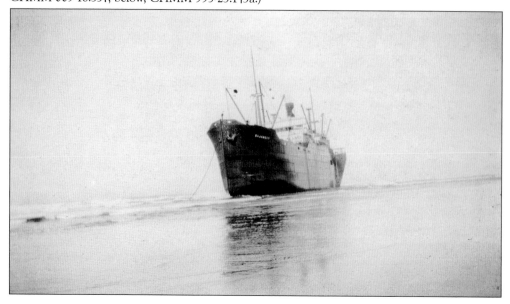

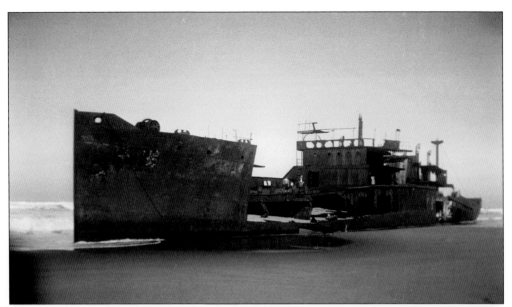

The *Sujameco* remained intact on the North Spit for many years. During World War II, the rusting hull was harvested for scrap metal. The bottom portion of the ship, however, was buried in the sand and inaccessible. In the above photograph, two men stand on the wreck after several portions of its hull have been removed. Year after year, shifting sands rebury the remains of the *Sujameco*. Then, when the winter storms arrive, the ship is once again revealed. (Above, CHMM 009-16.394; below, author's collection.)

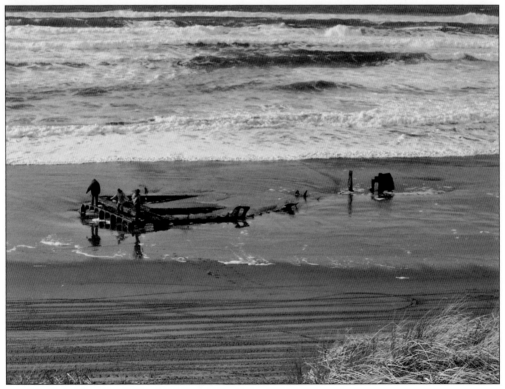

Although the appearance of the *Sujameco* is an annual occurrence, what the *World* newspaper called "one of the best exposures in years" took place while this book was being written. These photographs were taken while standing on the overlook (to the right of the Horsfall Beach parking lot). The entire ship was exposed from bow to rudder. The people standing on the beach help to demonstrate the size of the vessel. It is amazing that this much of the ship has survived in the sand for more than 80 years. (Both, author's collection.)

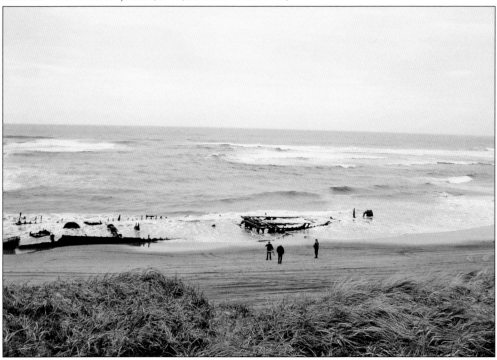

Three

THE COOS BAY JETTIES

The two Coos Bay jetties are important because they protect the harbor entrance, maintain the channel depth, and prevent large waves from breaking across the river bar. The history of the jetties and their construction is complicated; it took many years, several pleas for government funding, and one failed attempt. The U.S. Army Corps of Engineers first suggested building the jetties in the late 1870s. At the time, the depth of the Coos Bay channel fluctuated and was often affected by storms and currents. Some sailing vessels were forced to wait up to three months to leave due to unfavorable conditions.

The first jetty, which began near Fossil Point on the east side of the bay, was a failure. It used a crib method that had little effect on the channel depth and did not prevent the build up of shoals. The project was abandoned, and most of the jetty became submerged. As a result, it became a navigational hazard. The engineers then shifted their focus to the north jetty, which was completed in 1901. It began on the North Spit and extended out into the ocean, creating a curved shape. Initially, it maintained a channel depth of 20 feet. But much of the rock used in the construction was composed of a sedimentary material that disintegrated rapidly under the continual barrage of waves, and the water depth began to fluctuate. The south jetty was completed in 1928. It extended west from Coos Head, which is a point on the south side of the entrance to the Coos Bay.

After the completion of the jetties, the Coos Bay became an international port. Ships from around the globe could safely import and export goods. The jetties have successfully reduced the number of shipwrecks on the Coos Bay bar. However, every few years the jetties require additional work to repair the damage created by wave action.

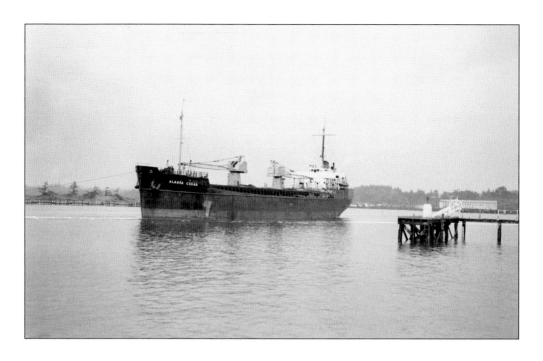

The motor vessel *Alaska Cedar* was built at Camden, New Jersey, in 1944. The 2,444–gross ton ship was originally called the *John L. Mason*. On December 2, 1962, the steel-hulled vessel attempted to cross the Coos Bay bar in rough conditions. Its engines became disabled, and the boat drifted onto the north jetty. All 24 crewmen were safely rescued. (Above, CHMM 009-16.1085; below, CHMM 009-16.422b.)

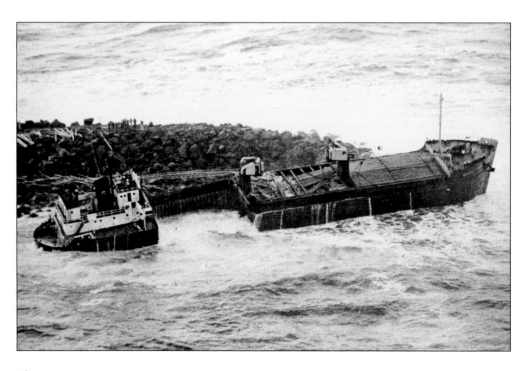

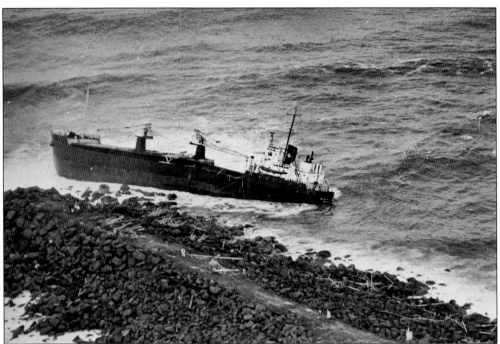

Disaster struck while the coastwise motor vessel *Alaska Cedar* was attempting to leave the Coos Bay with a full load of lumber on December 2, 1962. The disabled ship struck the north jetty where the waves continued to slam it against the rocks. The cargo of lumber was scattered across the jetty. In the above photograph a vertical crack has begun to form in the hull. A helicopter has landed on the jetty, and its two passengers are inspecting the wreck. The crack continued to grow, and the *Alaska Cedar* broke into two pieces within a matter of days. Fortunately, no lives were lost during the accident. The *Alaska Cedar* was having a bad year. The ship grounded near Port Orford in April but was refloated and repaired. Just a few months later, it became a total loss. (Above, CHMM 992-8-2724; below, CHMM 007-25.465.)

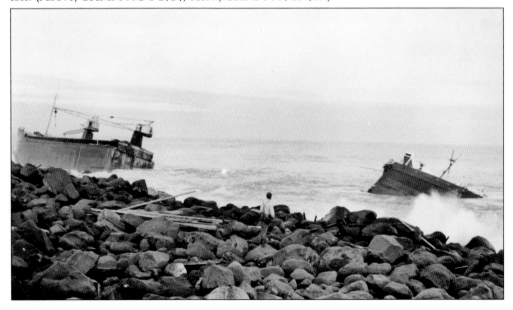

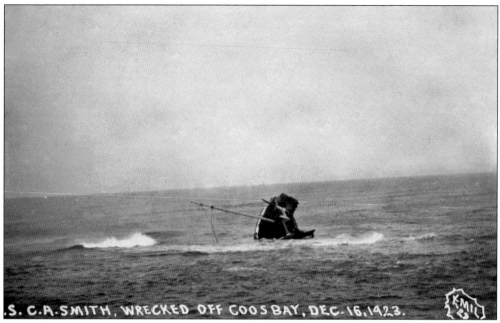

The 1,871–gross ton steamship C. A. *Smith* was built at the Kruse and Banks Shipyard in North Bend in 1917. On December 16, 1923, the C. A. *Smith* struck the Coos Bay's north jetty while attempting to cross the bar in heavy seas. The ship was fully loaded with 1.5 million board feet of lumber. The vessel cracked amidships and eventually broke up. (CHMM 992-8-2875.)

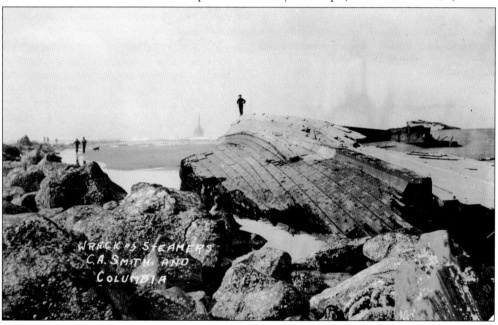

Although reports vary, between four and nine crewmen were lost during the wreck of the C. A. *Smith*. This stunning photograph shows the battered remains of the wooden hull on the beach. The steamship *Columbia* is visible on the ocean in the distance. There is a man standing on top of the wreck posing for the photograph. The accident has shifted from a tragedy to a tourist attraction. (CHMM 967-121o.)

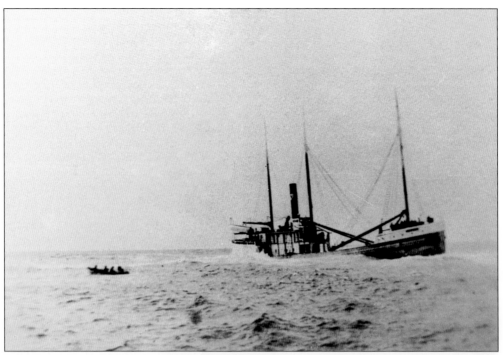

The steam schooner *Claremont* was built by John Lindstrom at Aberdeen, Washington, in 1907. The 747–gross ton vessel stranded on Coos Bay's north jetty in 1915. In the above photograph, a lifeboat is leaving the damaged ship. (CHMM 009-16.341.)

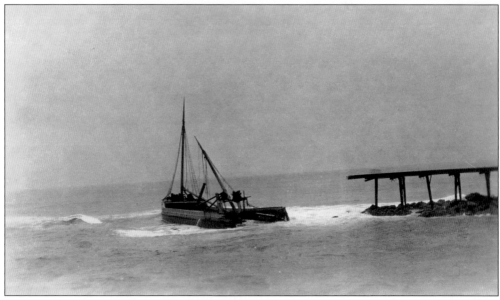

On May 22, 1915, the *Claremont* was struck by a large wave while attempting to enter the Coos Bay. The ship strayed off course and struck the north jetty. The seas continued to batter the stranded ship, and within days it broke up. In this photograph a portion of the vessel remains in the water with the storm-damaged jetty in the background. (CHMM 982-232.)

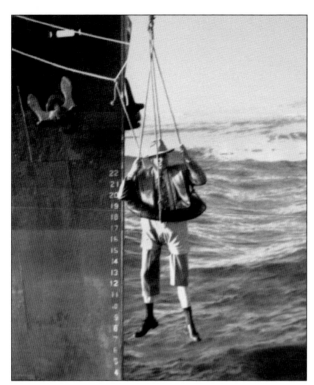

The dredge *Col. P. S. Michie* rescued 22 people from the *Claremont* by breeches buoy, which is a rope-based rescue device. As demonstrated at left, it resembles a life ring with an attached pair of pants (hence the name "breeches buoy"). The device essentially works like a zip line to rescue one person at a time from a disabled ship. Within two days, the wooden hull of the *Claremont* broke apart in the rough surf. (Left, CHMM; below, CHMM 982-190.67.)

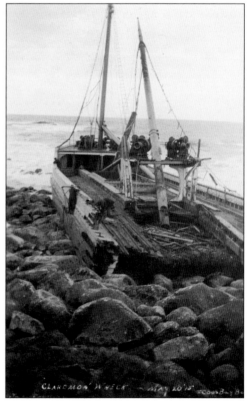

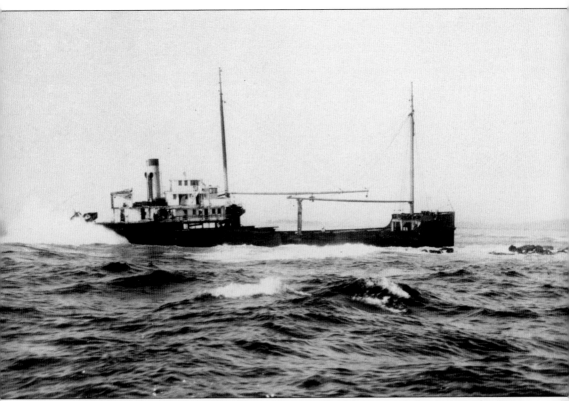

The steel-hulled steam schooner *Columbia* struck a submerged object while crossing the Coos Bay bar on February 17, 1924. The accident stopped the ship's engine and caused it to swerve out of the channel where a strong current forced it onto the north jetty. The vessel, which was built by Hamlon and Hollingsworth in Wilmington, Delaware, in 1912, was 1,923 gross tons. By the following day, all 65 passengers and crew had been safely rescued. Among the passengers was a newlywed couple traveling under false names in order to surprise the wife's mother. While waiting to be rescued, they became worried that if anything went wrong no one would know how to contact their families. (CHMM 009-16.353.)

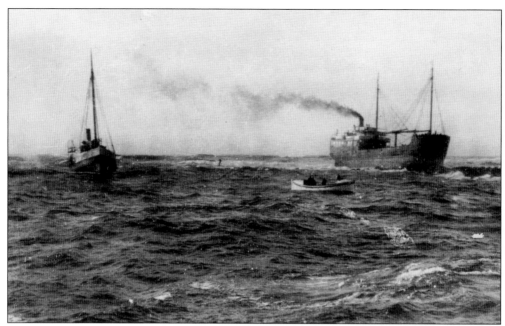

There is a lot of activity in the above photograph. The ship on the right is the *Columbia*, which grounded on the north jetty of the Coos Bay in February 1924. The ship on the left is the *Cleone*, which is in the process of rescuing the passengers and crew via a breeches buoy device similar to a zip line. There is a man traveling between the two ships. Meanwhile, the small boat in the center of the photograph contains a Coast Guard crew. After transferring rescue equipment onto the *Cleone*, they stayed to supervise the rescue operations. In the photograph below, the passenger has safely arrived at the *Cleone* where the crew is ready to assist him aboard. (Above, CHMM 007-25.35; below, CHMM 007-25.32.)

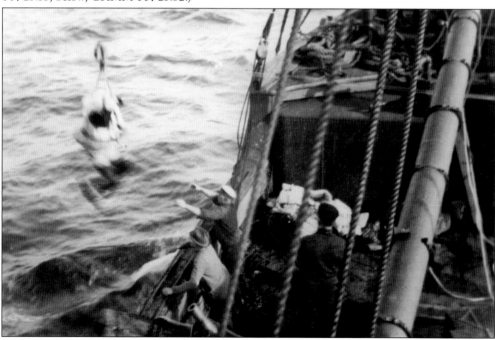

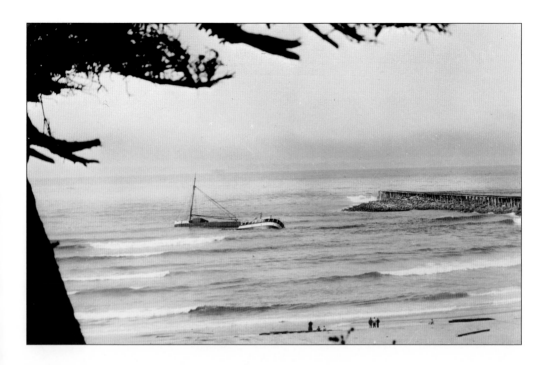

The steam schooner *Fort Bragg* was built at Fairhaven, California, in 1910. The wooden-hulled vessel was 912 gross tons. On September 7, 1932, the *Fort Bragg* attempted to cross the Coos Bay bar in a thick fog. It struck the beach just south of the south jetty. Some reports claimed that the captain, John Samuelson, became confused and believed that his ship was traveling between the two jetties. The Coast Guard successfully rescued the passengers and crew from the stranded vessel. The following day, the *Fort Bragg* slid off the jetty and into the water where the hull broke into two pieces. (Above, CHMM 009-16.358; below CHMM 009-16.359.)

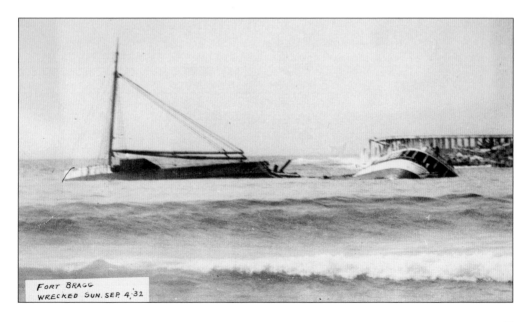

FORT BRAGG
WRECKED SUN. SEP. 4, '32

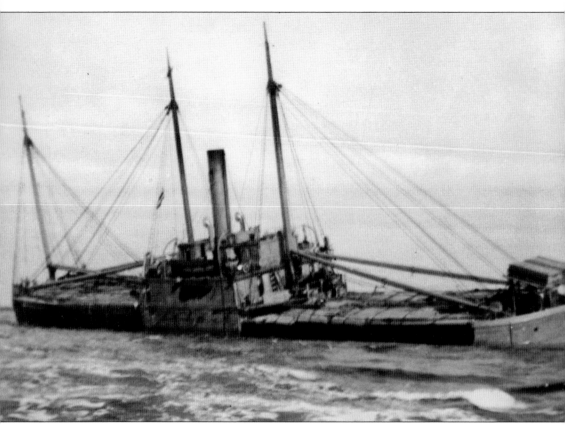

The story of the *George L. Olson* is complicated and often confusing. The steam schooner was built at the W. G. Stone Shipyards in Oakland, California, in 1917 as the *Ryder Hanify* (not to be confused with the other *Ryder Hanify* that was built in North Bend, Oregon, in 1920). The wooden-hulled vessel was capable of carrying up to 1.4 million board feet of lumber. Although it was built for J. R. Hanify and Company, it was soon sold to the French government and renamed the *Gabriel*. Five years later, the ship was purchased by Oliver J. Olson and renamed the *George L. Olson* (not to be confused with the metal hulled *George Olson* that was built in 1919). The *George L. Olson* worked in the Northwest as a lumber schooner for over 20 years. (CHMM 007-25.243.)

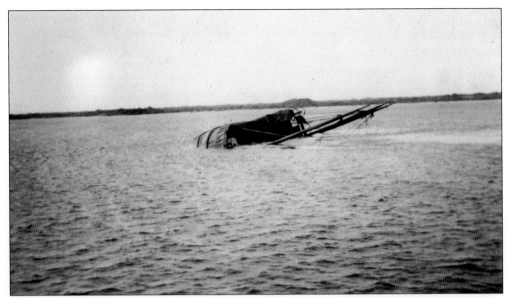

On June 23, 1944, the *George L. Olson* struck Coos Bay's north jetty before drifting and grounding on Guano Rock. The ship was refloated and towed across the Coos Bay bar, but it grounded on the mudflats between Barview and Charleston where it was declared a total loss. Salvage of the cargo of over a million board feet of lumber lasted six months. (CHMM 007-25.242.)

The Charleston Baptist Community Church was built from lumber from the wreck of the *George L. Olson*. The congregation salvaged more than 500,000 board feet of lumber. The majority of the work was done by five women and two elderly men since most of the young men were away at war. The building is still used by residents of the small fishing village. (CHMM 986-N565b.)

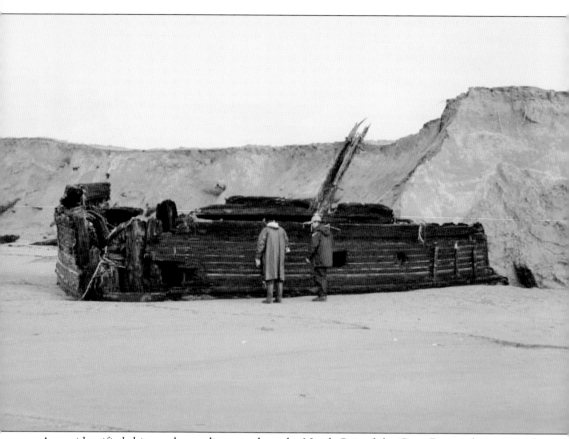

An unidentified shipwreck was discovered on the North Spit of the Coos Bay in the spring of 2008. It had been a rough winter full of storms and high seas, which caused a great deal of beach erosion. Within a month, the wreck transformed from just a few pieces of exposed wood to the entire bow of a ship that had been buried in the sand dunes. (Author's collection.)

People began asking questions about the shipwreck, which was quickly becoming a tourist attraction. The media dubbed it the "mystery shipwreck." The wreck received an estimated 10,000 visitors over the next few months. Local authorities were forced to reroute traffic around the site. (Author's collection.)

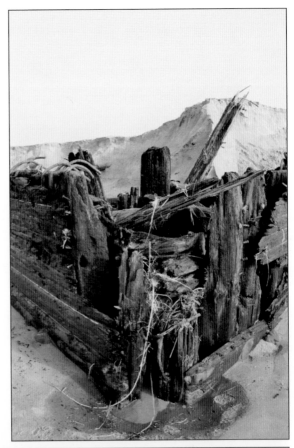

The Coos Historical and Maritime Museum, Bureau of Land Management, Oregon Parks and Recreation Department, and the National Oceanic and Atmospheric Administration worked together to investigate and research the shipwreck. They concluded that it was the *George L. Olson*. After the ship's cargo of lumber was salvaged, it was determined that the ship was too badly damaged to repair. It was intentionally beached on the North Spit in December 1944. Over the years, the ship was covered with sand and forgotten. (Author's collection.)

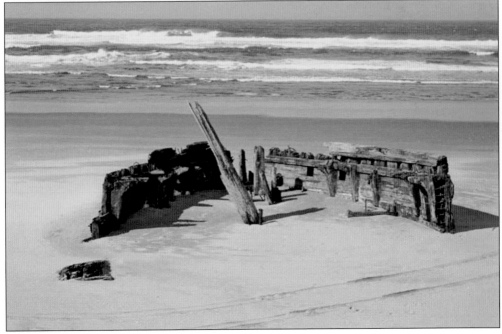

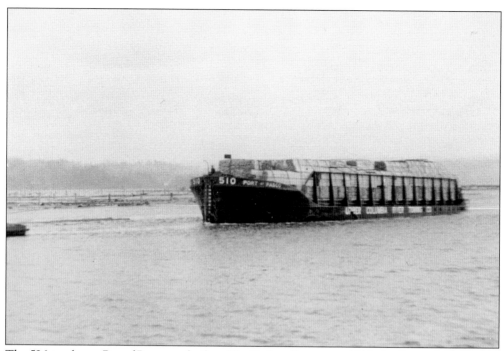

The 526-ton barge *Port of Pasco* was built at The Dalles, Oregon, in 1946. On December 12, 1953, the tugboat *Winquatt* was attempting to tow two barges loaded with lumber out of the Coos Bay when a large wave struck the *Port of Pasco*. The boat's towline broke, and it drifted onto the north jetty. The second barge suffered minor damage, but the tugboat managed to keep it in tow. The *Port of Pasco*'s back was broken when it collided with the jetty. The ship became a total loss. (Above, CHMM 009-16.401; below, CHMM 007-25.452.)

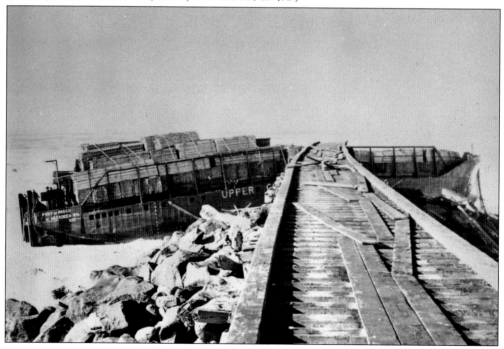

Four

THE COOS BAY

The Coos Bay is a horseshoe-shaped body of water that is located near the mouth of the Coos River. It is the largest natural harbor between San Francisco, California, and Puget Sound, Washington. The Coos Bay is approximately 15 miles long, and there have been numerous marinas and lumber-loading facilities built along its banks at Charleston, Empire, North Bend, and Coos Bay (formerly the city of Marshfield).

Historically, the Coos Bay waterfront was a busy place. Many of the buildings were constructed on pilings that extended out over the mudflats and water. Much of this land has since been filled. Numerous vessels, which varied greatly in type and purpose, visited the docks to conduct their business. The long wharf was often crowded with passengers and freight. While larger vessels transported cargo and passengers to faraway destinations, numerous riverboats traveled along the many rivers and sloughs. They were nicknamed the "mosquito fleet" because they were constantly zipping from one place to another while transporting everything from schoolchildren to milk from local dairy farms.

By 1884, the Coos Bay had established itself as a shipping port. Much of the area's trading was done with businesses in San Francisco. As the port grew, local shipbuilding became a major industry due to the need for vessels to transport goods to market. The majority of cargo shipped out of the Coos Bay region was related to the forestry industry and included logs, lumber, and wood chips. For a short period of time, the county also mined and sold coal. Today the Port of Coos Bay continues to export its forest products to outside markets and ranks among the largest lumber ports in the world.

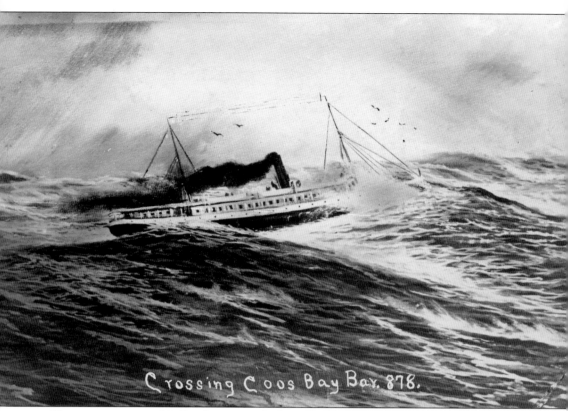

Crossing Coos Bay Bar. 878.

The passenger steamship *Breakwater* was built at Chester, Pennsylvania, in 1900. The 1,065-ton iron-hulled vessel was built for the North Pacific Steamship Company. It regularly transported passengers up and down the West Coast. The *Breakwater* departed Coos Bay on January 4, 1908, on its way to Portland. Although bar conditions were not considered dangerously rough that day, the ship was soon struck by a large wave with enough force to splinter the bulwarks and damage the forecastle. Four people were injured in the incident. The vessel was forced to return to North Bend so the injured could be hospitalized. One died without regaining consciousness. The *Breakwater* was repaired and sailed the following day. (CHMM 961-33.2.)

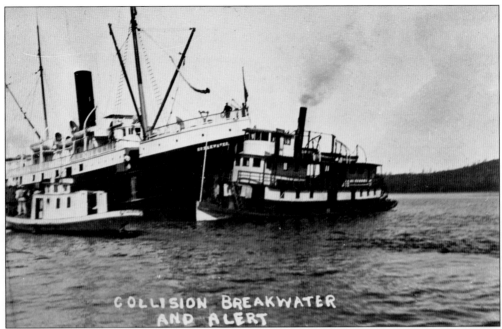

COLLISION BREAKWATER AND ALERT

Miscommunication caused the collision of the passenger steamer *Breakwater* and the stern-wheel steamer *Alert* on October 9, 1909. The *Alert* was moored at the larger ship's dock. When the captain saw the *Breakwater* approaching, he assumed that the other captain would want his usual spot and started to move his boat. Unfortunately, the captain of the *Breakwater* was unaware of the other man's intentions and accidentally plowed into the *Alert*. The riverboat quickly filled with water and sank. The crew jumped overboard and was safely taken aboard the *Breakwater*. Several weeks later, the *Alert* was raised and repaired. (Above, CHMM 992-8-2277; below, CHMM 009-16.1249.)

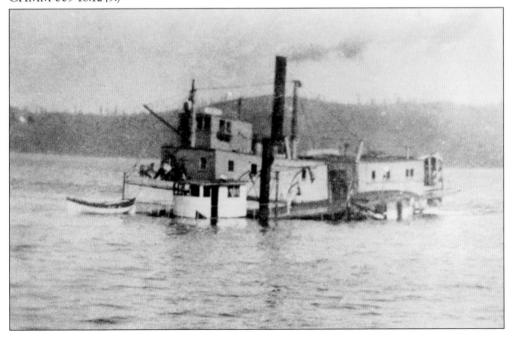

On December 4, 1986, the Swedish freighter *Elgaren* struck the McCullough Bridge, which is located on the Coos Bay, while attempting to travel beneath it. Witnesses said that there was a large "crackling metal" sound and that the entire bridge shook after the collision. This photograph shows some of the damage, which included gashes in the bottom beams. A structural cross brace is dangling beneath the bridge. (CHMM 995-1.86786.51.)

In addition to cutting 2-inch gashes into the main support beams at the peak of the bridge, the collision caused the outside edges of the beams to bend outwards as demonstrated in the photograph. Fortunately, no one was injured in the accident. Further investigation determined that the roadway itself and the water main pipe that is supported beneath it were undamaged. (CHMM 995-1.86786.106.)

The *Elgaren* arrived at the Coos Bay on December 4, 1986. The ship safely crossed the bar and proceeded up the bay. It passed through the Southern Pacific Railroad swing bridge without incident. A later investigation, however, determined that the ship was traveling too fast. There was a roll-on, roll-off ramp located at the stern of the freighter. It was necessary for the ramp to be a vertical position in order to pass through the railroad bridge, but the crew then needed to lower the ramp in order to clear the arch beneath the McCullough Bridge. Due to the speed the ship was traveling, the crew did not have enough time. Although the bridge received substantial damage in the collision, the only damage to the *Elgaren* was two bent metal plates at the top of the ramp's left support column. The damage is barely visible in this photograph of the *Elgaren*'s loading ramp. (CHMM 995-1.86786.34.)

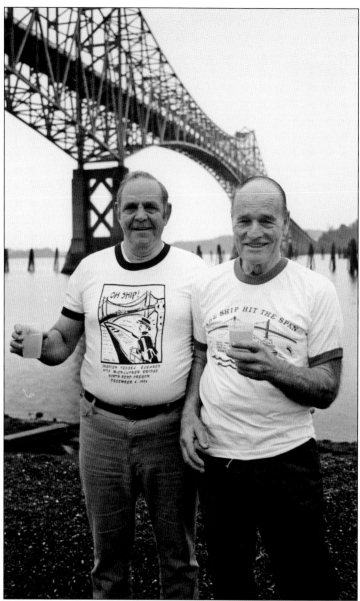

Traffic on Highway 101 was detoured around the bridge after the accident. The 15-mile detour was an enormous inconvenience, but many Coos County residents chose to see the humor in the situation. Several local business groups, with the support of the North Bend City Council, started a T-shirt and bumper sticker campaign to thank travelers for their patience while the bridge was being repaired. At left, two unidentified men model the T-shirts. One reads "Oh Ship!" while the other reads "The Ship Hit the Span." Both include the name of the ship, *Elgaren*, and the date. The bumper stickers featured a drawing of a bandage around the bridge and the word ouch. (Left, CHMM 995-1.86840.1; below, CHMM 997-D57.)

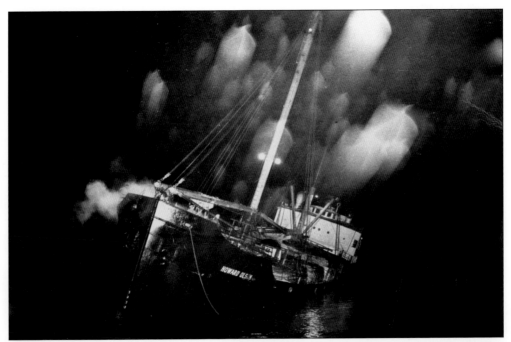

The *Howard Olson* endured a minor mishap on the evening of February 23, 1950. The steel steam schooner began leaning to one side after it left the Central Dock on the Coos Bay with a full load of lumber. The *Howard Olson* returned to the dock where its cargo was adjusted and the ship returned to an upright position. The steamer departed without incident a few days later. (Above, CHMM 009-16.1220; right, CHMM 009-16.1221.)

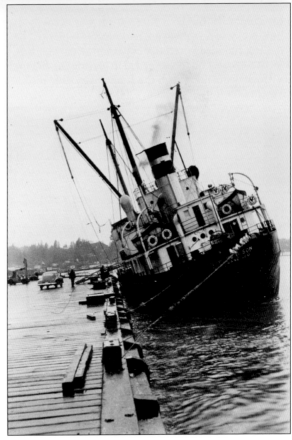

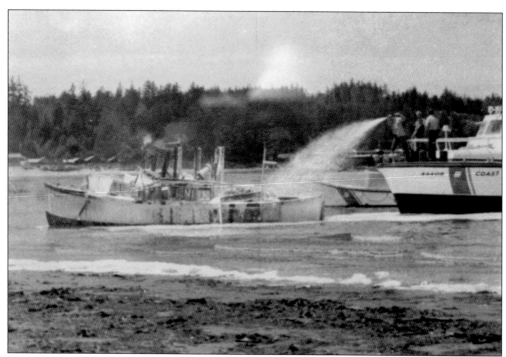

The 25-foot fishing boat *Kathy Lynn* was severely damaged by an explosion on July 15, 1974. The vessel was docked at a Charleston fish plant. The crew had just finished unloading fish and refueling the boat when the explosion occurred. It is believed that it was caused by gas fumes. The U.S. Coast Guard succeeded in getting the fire under control within 15 minutes. Fortunately, the three people on board the *Kathy Lynn* only received minor injuries in the incident. (Above, CHMM 009-16.1392a; below, CHMM 009-16.1392.)

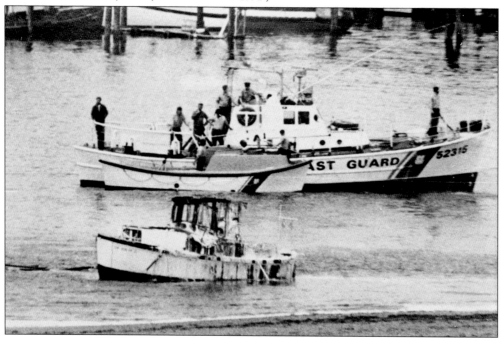

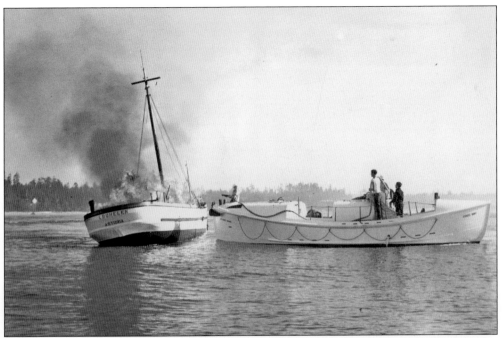

A tragic accident occurred aboard the fishing boat *Louhelen* on March 15, 1947. The boat was waiting to cross the Coos Bay bar on its way to sea when one of its gas tanks exploded without warning. It had 700 gallons of gasoline on board. The vessel caught on fire, and the second tank exploded a few minutes later. One of the four crewmen lost his life in the accident. The other three suffered minor injuries. The cause of the explosion remains unknown. (Above, CHMM 007-25.456; below, CHMM 995-1.869.2.)

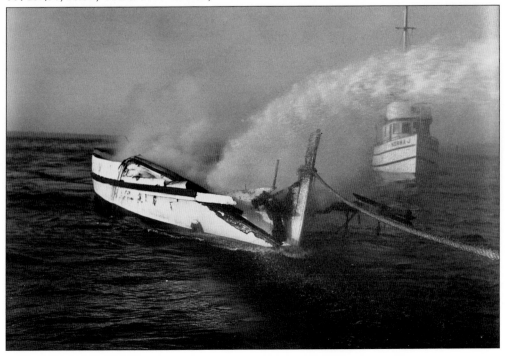

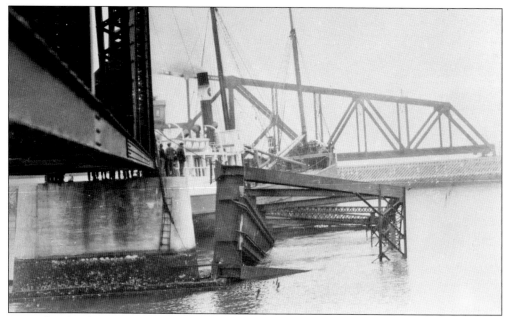

Around midnight on March 8, 1924, the steam schooner *Martha Buehner* hit the Southern Pacific railroad bridge. It struck with enough force to knock one of the bridge's 80-foot steel spans off its concrete pier and into the Coos Bay. The ship then collided with the span. It required the assistance of the tugboat *Oregon* to pull the vessel free. (CHMM 992-8-2726.)

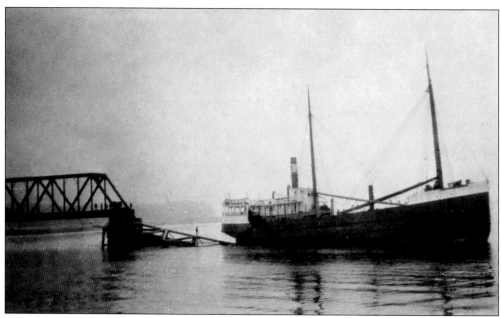

The wooden-hulled *Martha Buehner* began its career in 1911 as the A. M. *Simpson*. The 193-foot schooner was built for the Simpson Lumber Company. In 1916, it was sold to the Buehner Lumber Company where Henry Buehner renamed the ship after his wife. During World War II, it was used as a training vessel for merchant marine cooks. (CHMM 992-8-2728.)

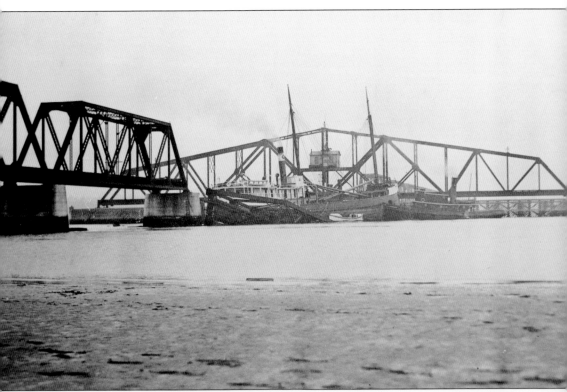

An investigation was conducted after the *Martha Buehner* struck the Coos Bay railroad swing span bridge in 1924. The incident was surrounded by controversy. Capt. J. S. Johnstad claimed that the bridge lights were obscured from view, which caused him to proceed with caution. A local newspaper that reported on the accident disagreed and claimed that the night was clear. Regardless of the visibility, the vessel was traveling approximately 80 feet outside of the shipping channel when it struck the bridge. Captain Johnstad had his license suspended for six months as a result of the incident. (CHMM 009-16.378.)

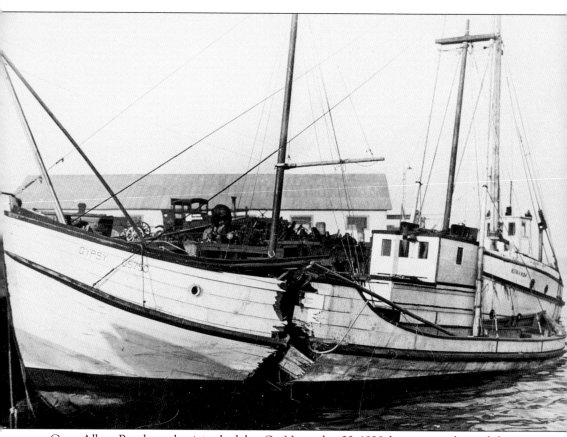

Capt. Albert Baach was having a bad day. On November 23, 1928, he attempted to sail the steam schooner *Prenties* up the Coos Bay. The ship encountered thick fog that disoriented the captain and caused him to stray into the mud on the east side of the channel. Baach then reversed his engine to pull his boat free but backed across the channel with too much force. He rammed into the side of the 46-foot fishing boat *Gypsy* that was moored to a floating dock. The *Gypsy*, shown here, was struck so hard that it was shoved onto the dock and received a large hole in the port side. The unfortunate Captain Baach then managed to swing the *Prenties* back across the channel where he struck the mud a second time. It took more than two hours and the combined efforts of the tugs *Coos King* and *P. E. Philips* to pull the *Prenties* free. Surprisingly, the ship suffered no damage and returned to work that afternoon. (CHMM 009-16.1262.)

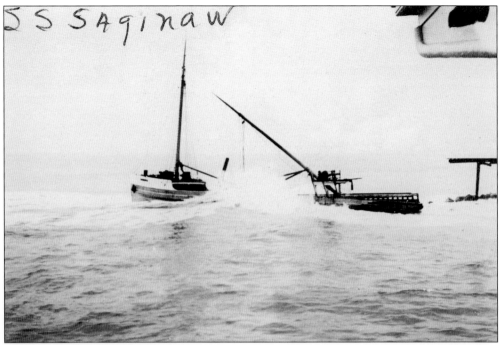

SS Saginaw

The steam schooner *Saginaw* struck a rock in Blanco Reef on August 11, 1911. The ship was transporting a cargo of general merchandise, cement, and asphalt when it encountered a thick fog and strayed too close to the reef. The vessel sprang a leak. The steam schooner *Redondo* came to its aid and succeeded in towing it as far as the entrance to the Coos Bay. The *Saginaw*'s crew was forced to throw its deck load overboard before it could cross the bar. The tugboat *Gleaner* assisted the *Redondo* in towing the waterlogged vessel into the Coos Bay. (Above, CHMM 982-190.77; below, CHMM 007-25.167.)

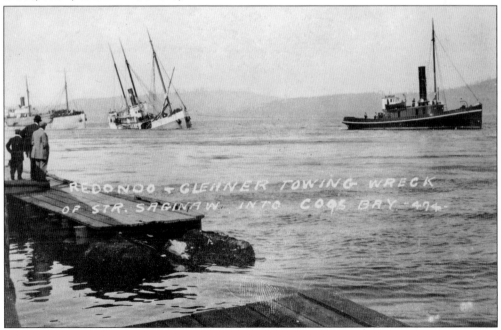

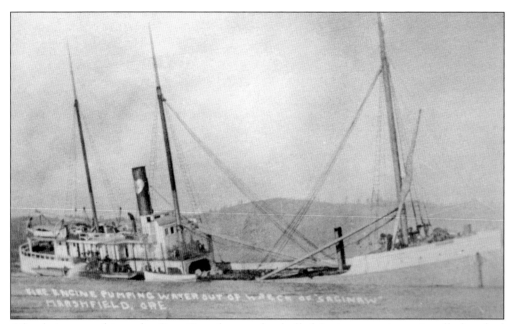

After being towed into the Coos Bay, the wooden-hulled *Saginaw* was intentionally beached across the bay from Marshfield (now the city of Coos Bay). The water was pumped out by the Marshfield Fire Department's steam fire engine. The *Saginaw* was patched and transported to Portland for permanent repairs. (CHMM 007-25.46.)

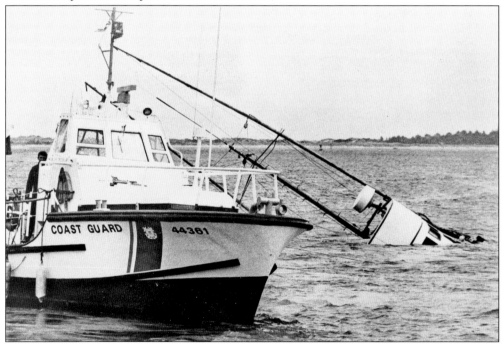

On July 19, 1974, the 46-foot fishing vessel *Glendale* struck a sunken log near the Charleston Boat Basin. The collision created a 3-foot-by-5-foot hole in the hull. The Coast Guard had difficulty keeping the vessel afloat while towing it ashore. The *Glendale* was repaired and returned to service. (CHMM 009-16.1391.)

Five

THE COQUILLE RIVER BAR

More than 100 vessels have been lost near the Coquille River bar through the years. Following the coastline, the Coquille River is located 13 miles south of the Coos Bay. Historically, many of the problems mariners faced at this location were similar to those at the Coos Bay bar: shifting sand to the north, rocky outcroppings to the south, and seasonal winds and fog. However, the mouth of the Coquille River is shallower. In the late 1800s, many vessels bypassed the port because the depth of the water could be as little as 3 feet.

A series of improvements eventually drew more ships to the area. In the late 1800s, Tupper Rock was blasted apart and used to construct the south jetty. The Coquille River Lighthouse, which was originally built on an island and connected to the mainland by a wooden walkway, began operating in February 1896. The island was later connected to the mainland during the construction of the north jetty. Finally, the U.S. Army Corps of Engineers began dredging the harbor entrance. Currently, the corps maintains depths of 13 feet on the Bandon bar and 14 feet inside the boat basin.

In the area's early history, the Coquille Indian tribe had a village near the mouth of the Coquille River. In the mid-1800s, the city of Bandon was established by Henry Baldwin and George Bennett at the same location. Many early pioneers panned for gold on the beaches near Bandon. As the town grew, logging, shipbuilding, commercial fishing, and agriculture were all major industries. Today the economy has shifted, and Bandon has become a popular tourist destination.

In February 1992, an article in *Sea Magazine* called the Coquille River "one of the most challenging harbor entrances on the West Coast." The same source claimed the "most important thing to know about the Bandon bar is that it lays flat, meaning that [it] will look tame until a series of waves come along." Although the Coquille River bar remains a challenge for mariners, the combination of caution, harbor improvements, and modern navigational equipment has greatly reduced the risk.

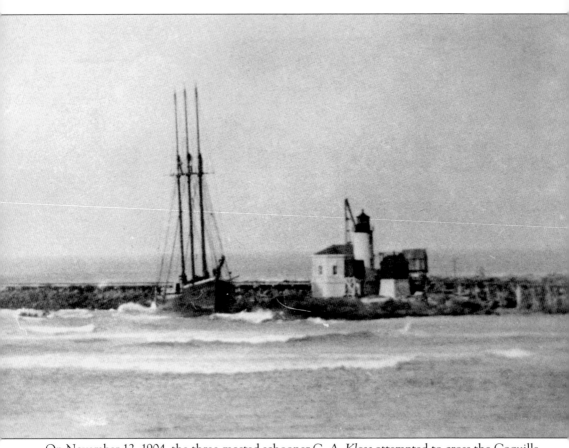

On November 12, 1904, the three-masted schooner C. A. *Klose* attempted to cross the Coquille River bar during rough conditions. The ship drifted onto the north spit near the lighthouse. A U.S. Life-Saving crew managed to pull the vessel free by first running a heavy rope from the ship to the south jetty. They then used a steam donkey engine to pull the C. A. *Klose* off the north spit. (CHMM 007-25.6.)

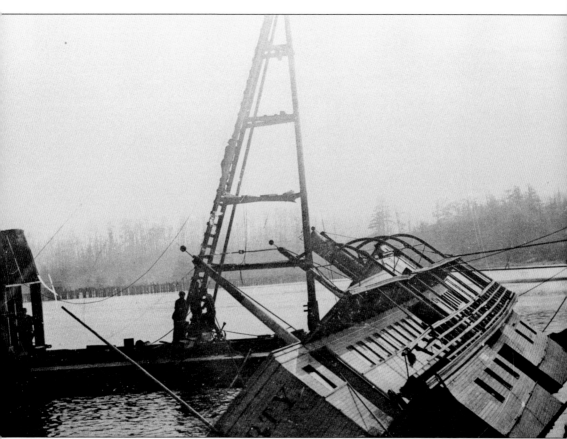

The stern-wheel steamer *Liberty* was built by Carl Herman at Bandon, Oregon, in 1903. The 174-ton boat was used to transport passengers in the Coquille River area. On the night of April 19, 1907, the *Liberty* was tied up at a dock on the Bandon waterfront. The riverboat had no condenser, so its owner was using city water for the boat's boiler. There was a waterline connecting the boat directly to the city of Bandon's water supply. All went well until somebody turned the water on during the night. This caused the boat to fill with water and sink. On April 23, the life-saving crew used barges to raise the *Liberty* high enough for its deck to be above the water line. The boat was then pumped out and repaired. (CHMM 009-16.1807.)

The scow schooner *Eureka* was built by M. Turner at Benicia, California, in 1887. The 123–gross ton vessel was owned by George W. Hume. On November 30, 1899, Capt. A. F. Asplund attempted to sail the *Eureka* across the Coquille River bar. (CHMM 009-16.330.)

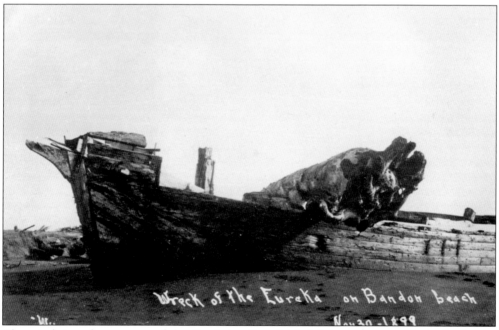

The wind ripped away part of the *Eureka*'s sails, which left it unmanageable in the heavy currents. The captain intentionally beached the vessel a mile north of the Coquille River's north jetty. The entire crew reached shore safely, but the wooden-hulled vessel soon broke up. (CHMM 007-25.8.)

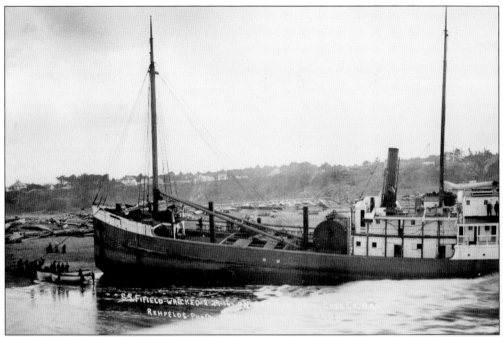

The steam schooner *Fifield* was built by Kruse and Banks at the company's North Bend shipyard in 1908. The wooden-hulled ship was 634 gross tons. The *Fifield* was owned by A. F. Estabrook at the time of its loss. (CHMM 009-16.390.)

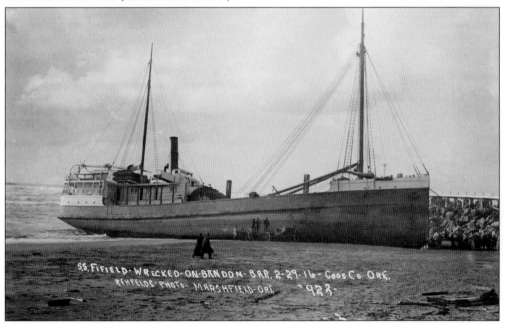

On February 29, 1916, the *Fifield* attempted to cross the Coquille River bar under the command of Captain Bakman. The steam schooner was driven off course by strong winds and heavy currents, which caused it to strike the south jetty. The *Fifield* became water logged but continued to drift before grounding on the nearby south spit. At low tide, the ship was accessible to beach visitors. (CHMM 960-204h.)

The cargo on board the *Fifield*, which was mostly hay, was successfully salvaged after the steam schooner grounded on the south spit of the Coquille River on February 29, 1916. Several attempts were made to pull the vessel off of the beach, but they all failed. Heavy seas eventually broke up the wooden hull. The damage to the *Fifield*'s bow is clearly visible in this photograph. (CHMM 981-284b1.)

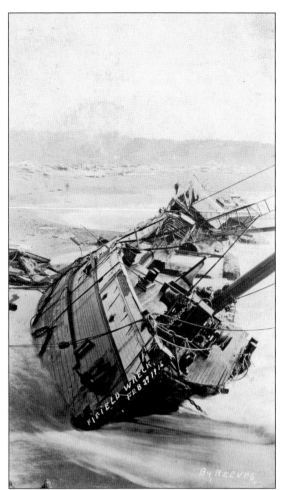

The hull of the *Fifield* remained on the south spit of the Coquille River for a short time. However, the continual barrage of waves at high tide combined with a violent storm began to take a toll. The ship eventually broke up. In the photograph below, the vessel's back has already broken. Several waves are carrying pieces of the ship out to sea. (CHMM 981-284u.)

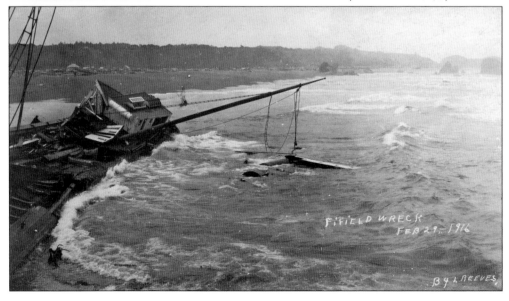

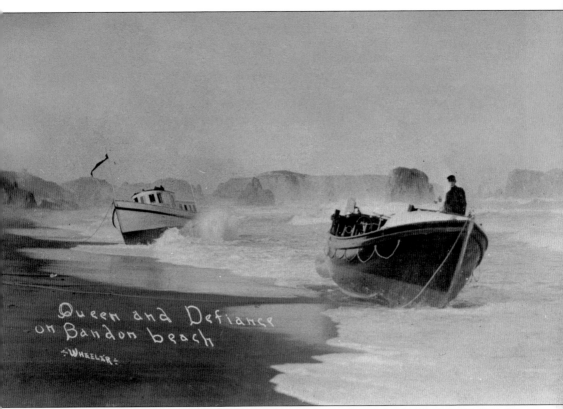

Queen and Defiance on Bandon beach
-WHEELER-

Sometimes rescue operations do *not* go according to plan. Such was the case on July 16, 1914. The trouble began when the 43-foot gas boat *Queen* encountered rough seas while attempting to cross the Coquille River bar. The vessel was struck by an enormous wave that smashed the window in its wheelhouse and flooded the engine room. Although the stalled motor was successfully restarted, a line on deck that had been washed overboard became tangled in the propeller. Capt. Hark Dunham sent out a distress call that was answered by the U.S. Life-Saving crew. They arrived on the scene with their power lifeboat, the *Defiance*, and attempted to tow the disabled *Queen* back to port. However, as the two vessels approached the Coquille River jetties, they were struck by several large waves. While the two boats struggled to remain upright, the towline managed to get tangled up in the *Defiance*'s propeller. With both engines disabled, the life-saving crew tried without success to row the boats to safety. Both vessels drifted south where they washed ashore. (CHMM 992-8-1671.)

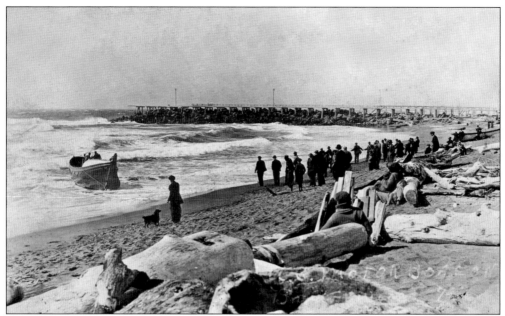

On July 16, 1914, the boats *Queen* and *Defiance* washed up on the beach near Bandon after a failed rescue operation. Fortunately, the crews of both vessels reached shore safely. The only injuries were some cuts that Captain Dunham, of the *Queen*, received when a large wave smashed his wheelhouse window. Above, a large crowd of onlookers has gathered on the beach to watch the U.S. Life-Saving crew refloat the power lifeboat, the *Defiance*. As for the *Queen*, all attempts to pull it back into the sea failed. It was instead pulled across the sand spit and refloated on the Coquille River. Fortunately, the boat sustained little injury. It was repaired and departed for Coos Bay on July 27 where it assisted in the construction of the Southern Pacific Railroad Bridge. (Above, CHMM 992-8-1672; below, CHMM 009-16.1005.)

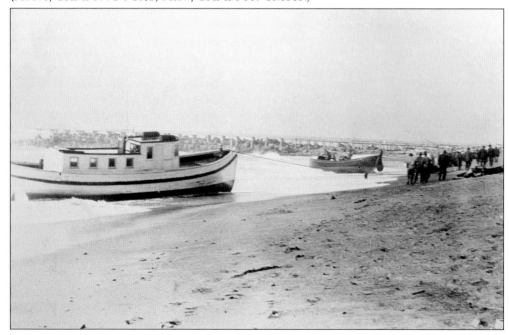

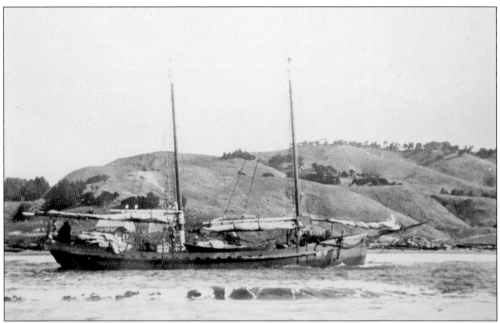

On April 24, 1915, the gas schooner *Randolph* capsized on the Coquille River bar with the loss of three lives. One member of the crew managed to swim safely ashore, but two others became trapped in the ship's hull. They were Captain Anderson and engineer Frank Colvin. Rescuers were forced to cut a hole in the hull of the submerged vessel in order to release the men. According to one source, as Frank Colvin climbed out of the hole he had his pipe in his mouth and calmly asked his companions, "Does anyone have any dry matches?" The 42–gross ton vessel was built by the Herman Brothers on the Coquille River in 1910. The schooner became a total loss. (Above, CHMM 009-16.1711; below, CHMM 992-8-1676.)

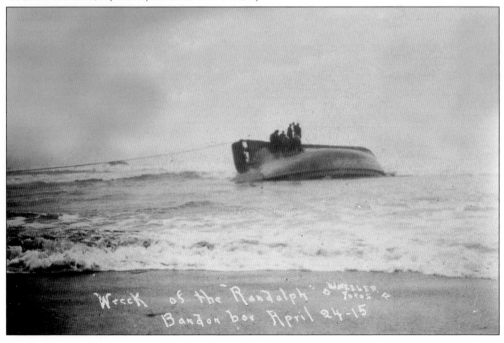

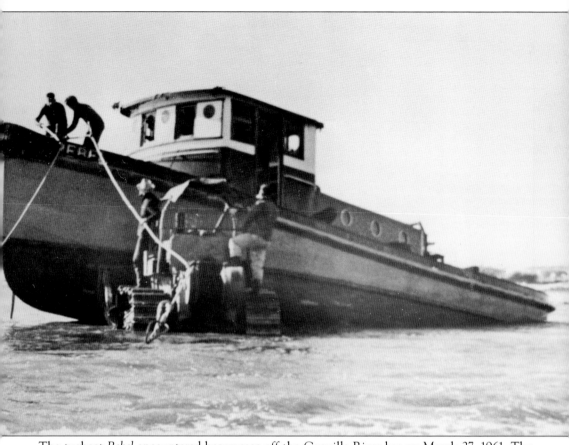

The tugboat *Rebel* encountered heavy seas off the Coquille River bar on March 27, 1961. The captain, A. T. Peterson, was lost when the boat capsized. The deck hand was forced to cling to the overturned hull until he could be rescued. This photograph was taken after the tugboat washed ashore. Several men have succeeded in returning the boat to an upright position. The *Rebel* was successfully salvaged and repaired. It remained in service on both the Coquille River and the Coos Bay for several more years. In 1966, the vessel was sent to Vietnam. (CHMM 007-25.203.)

Six

THE COQUILLE RIVER JETTIES

Historically, the mouth of the Coquille River often shifted its location. The combination of storms, tides, and shoaling could force the river to empty into the sea anywhere between Whiskey Run beach and Table Rock, which are located several miles apart. In the late 1890s, two jetties were constructed in order to force the channel to stay in one location.

According to engineer James Polhemus, "This part of the coast is one of the roughest and most exposed places in the world . . . due to the . . . tremendous reach of the ocean to the westward." He went on to claim that for many years it was generally believed that it would be impossible to build jetties on this part of the Pacific Coast that could "withstand the force of these waves." His concerns were justified. Although the initial construction of the two jetties took place between 1894 and 1912, the work was often delayed due to limited funding and the need to continually repair sections of the jetty that were damaged by storms. To this day, additional repairs and modifications to the jetties are necessary every few years in order to maintain a safe channel for ships to travel.

Perhaps the most interesting piece of information about the Coquille River jetties is that one contains the hull of a ship. After the *Oliver Olson* stranded on the south jetty of the Coquille River on November 3, 1953, the decision was made to use cutting torches to remove the top portion of the ship's hull. The bottom portion was left behind. It was then filled with rocks and incorporated into a 450-foot extension to the south jetty. The project was completed in the summer of 1954.

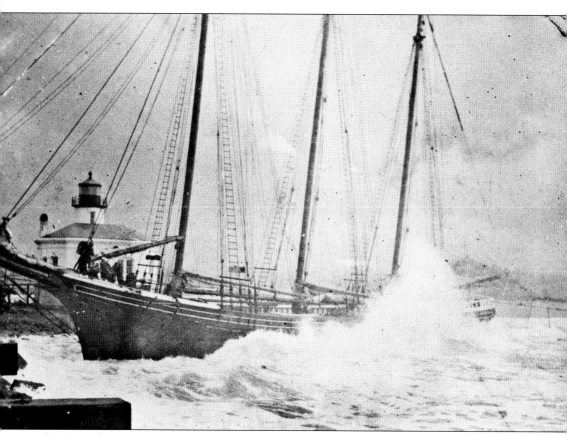

On December 29, 1905, the three-masted schooner *Advance* attempted to sail across the Coquille River bar with a cargo of hay, general merchandise, and explosives. Strong currents caught the ship and pulled it onto the north jetty. The life-saving crew succeeded in pulling the ship off with the assistance of a local tugboat, but the towline broke. The *Advance* drifted toward the beach where it grounded a second time. This photograph shows the stranded vessel being battered by waves. The Coquille River lighthouse is visible on the left. Salvage crews continued to work on the schooner. They finally succeeded in refloating the *Advance* in January 1906. (CHMM 009-16.795a.)

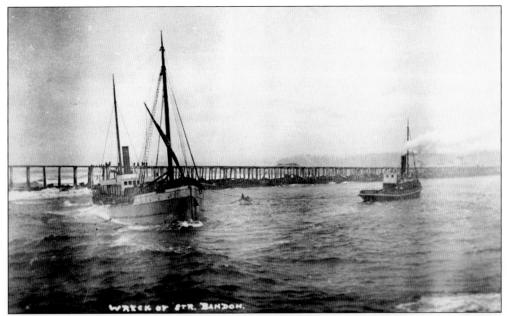

The schooner *Bandon* was built by the Kruse and Banks Shipyard in North Bend in 1907. Although the records are full of discrepancies, the 642–gross ton steamer's colorful career included at least six shipwrecks and numerous other maritime mishaps. (CHMM 009-16.375.)

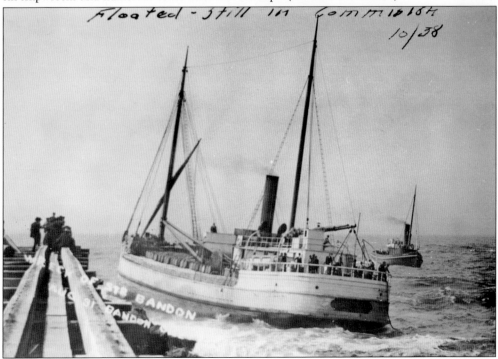

Heavy wind and strong currents caused the wooden-hulled *Bandon* to ground on the south jetty of the Coquille River on August 31, 1909. The U.S. Life-Saving crew rescued the schooner's passengers. A local tugboat pulled the steamer off the jetty and towed it back to the Port of Bandon. The *Bandon* was later towed to San Francisco to be repaired. (CHMM 007-25.204.)

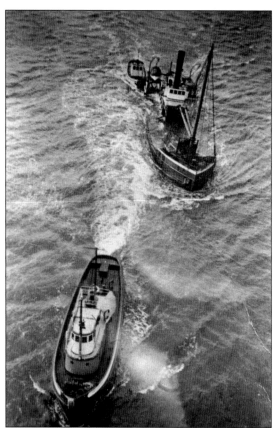

In February 1941, the steamer *Bandon* departed the Coquille River. It was transporting a cargo of 450,000 feet of lumber to San Francisco. On February 9, while traveling near the Oregon-California border, it encountered a severe storm. The wind battered the wooden-hulled vessel, and it began to leak. The crew was forced to jettison 175,000 feet of lumber in order to reduce the ship's weight. (CHMM 007-25.395.)

Although this prevented the ship's sinking, it still became water logged. The entire crew escaped in a lifeboat and was later picked up by the tanker *Solano* before being transferred onto the Coast Guard cutter *Shawnee*. The *Shawnee* towed the disabled *Bandon* up the coast to Coos Bay, where the tug *Port of Bandon* helped to transport the waterlogged ship across the Coos Bay bar. (CHMM 007-25.229.)

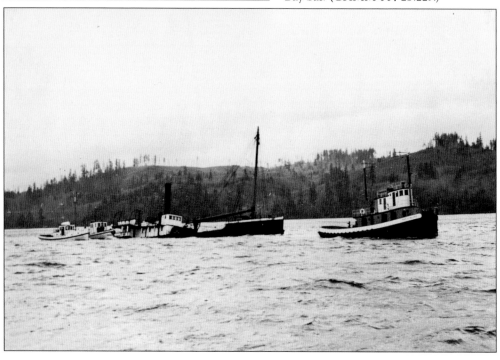

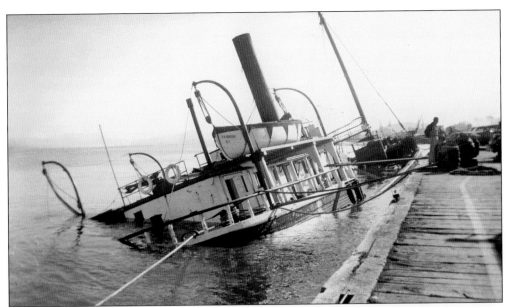

The Moore Mill and Lumber Company owned the *Bandon* when it wrecked in 1941. The owners decided it would be too expensive to repair the 34-year-old ship and instead towed the boat up the Isthmus Slough and abandoned it. Around 1944, it was sold to Mexican owners, but its boilers failed to pass inspection, and it was abandoned again. Capt. Sam Thompson later purchased the *Bandon* and transported it back to the Coos Bay where it was scorched by a dock fire. The *Bandon* was then towed to a Portland dock for repairs. The boat foundered at the dock and was abandoned once again. Several years later, the *Bandon* was towed to Columbia City, Oregon. It was then intentionally sunk in order to incorporate the hull into the breakwater. The battered old ship's adventures were finally over. (Above, CHMM 009-16.69b; below, CHMM 959-70.)

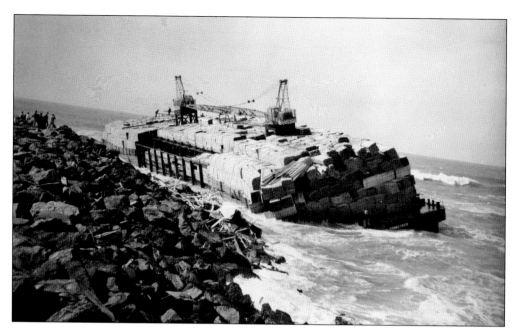

On March 19, 1964, the tugboat *Restless* attempted to tow the 300-foot barge *Cedar* out of the Coquille River. The *Cedar* was carrying a cargo of nearly 4 million board feet of lumber. Unfortunately, the tug experienced power failure, which forced it to release the barge. The *Cedar* drifted onto the south jetty where it began to take on water. After several days, the *Salvage Chief* succeeded in pulling the ship off the jetty and back onto the river. The *Cedar* sustained several holes in its port side. The boat was temporarily patched at the Port of Bandon but towed elsewhere for permanent repairs. In the photograph below, it has been pulled free and is being towed back to dock. (Above, CHMM 009-16.864; below, CHMM 009-16.859a.)

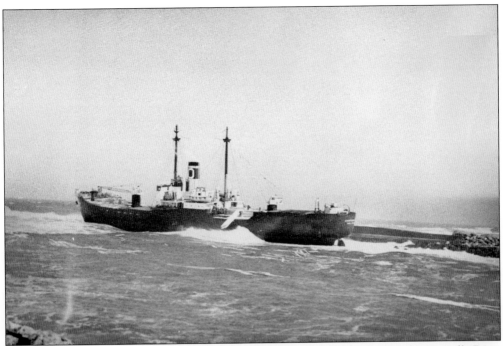

On June 7, 1952, the steel-hulled steamship *Cynthia Olson* attempted to cross the Coquille River bar while carrying a cargo of 1.6 million feet of lumber. The lumber carrier struck a shoal near the outer end of the north jetty and stranded. The ship was under the command of Capt. Anton Brix. The *Cynthia Olson*'s cargo was removed in order to reduce its weight. On June 15, the ship was successfully refloated by the tug *Salvage Chief*. It was then towed to Portland to be repaired. Nearly 80 percent of the bottom plates of the hull were damaged and needed to be replaced. The *Cynthia Olson* was owned by Oliver Olson and Company. The 3,117–gross ton vessel was built at Flensburg, Germany, in 1935. (Above, CHMM 009-16.366; below, CHMM 009-16.366a.)

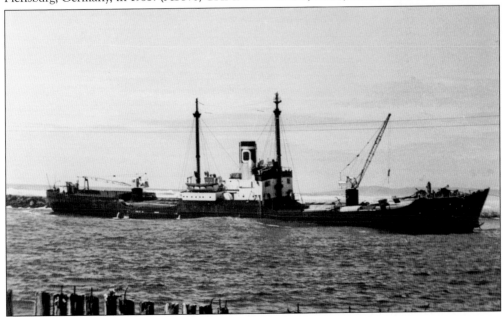

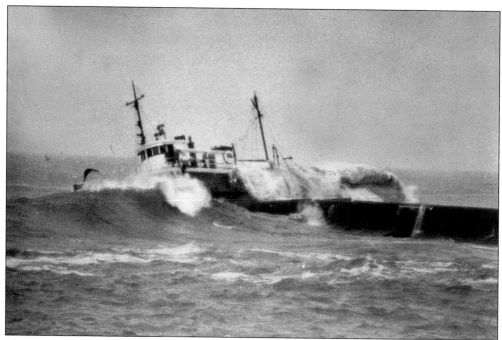

The tug *Elizabeth Olson* was originally called the *LT-374*. At 275 gross tons, it was built for the U.S. Army by Barbee Marine Yards at Seattle, Washington, in 1944. During its career, the vessel was also known as *Jack* and *Mary C. Cornell*. It was owned by the Olson Towing Company. (CHMM 992-8-1633.)

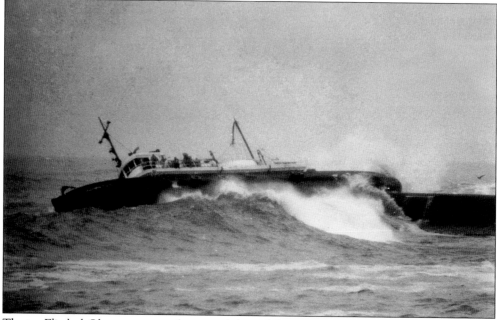

The tug *Elizabeth Olson* encountered steering failure while entering the Coquille River on November 30, 1960. The vessel, under the command of Capt. Charles May, was stranded on the north jetty. The sea was very rough that day, and the tug began to break up. In the above photograph, the seas continue to pound against the disabled vessel. (CHMM 992-8-1635.)

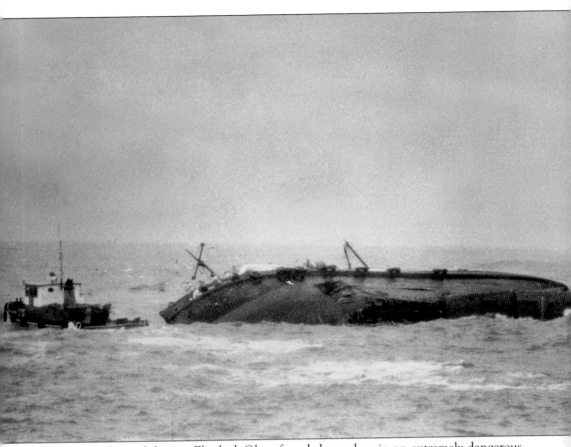

The crew members of the tug *Elizabeth Olson* found themselves in an extremely dangerous situation on November 30, 1960. Their vessel, which stranded on the north jetty of the Coquille River, was beginning to break apart in the rough seas. One of the crewmen escaped the ship by jumping onto the jetty. The other 10 men were rescued by the tugboat *Rebel*. It took the small boat several trips. Each time the *Rebel* backed up as close as possible to the stranded tug, several crewmen would jump on board. Although Captain May suffered a broken leg, the rest of the crew escaped serious injury. In the above photograph, the *Rebel* is dwarfed by the *Elizabeth Olson*, which is already lying on its side. Two large holes are beginning to form amidships. The jetty is barely visible on the right edge of the photograph. (CHMM 992-8-1637.)

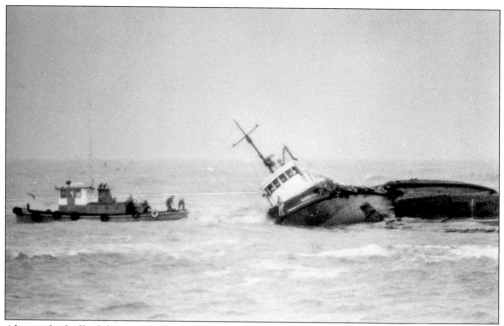

Above, the hull of the tug *Elizabeth Olson* has already fractured. As a result, the fore section has temporarily refloated. It appears that the only thing keeping the aft section from sinking is the portion of the Coquille River's north jetty that it is resting upon. There is a man standing on the bow, while two men can be seen standing on the stern of the tug *Rebel*. They are preparing to help the other man on board the safety of the smaller vessel. By the time the second photograph was taken, the *Elizabeth Olson* was in pieces. Part of its boathouse can be seen on the rocks of the jetty. Another tugboat has arrived on the scene to render assistance. The *Elizabeth Olson* was transformed from ship to rubble in 20 minutes. Fortunately, the entire crew was saved. (Above, CHMM 992-8-1639; below CHMM 992-8-1640.)

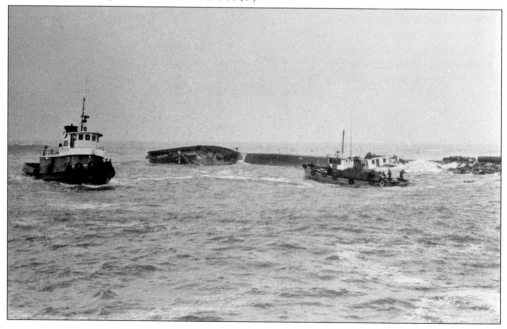

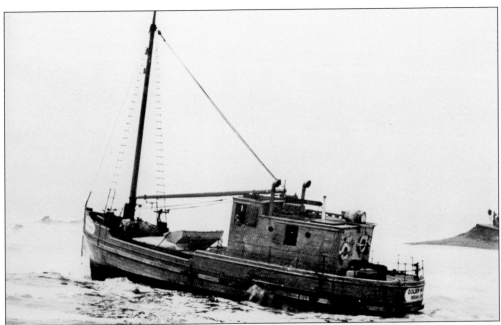

On March 29, 1936, the gas schooner *Golden West* encountered high seas while attempting to cross the Coquille River bar. The waves forced the ship onto the north jetty. The Coast Guard succeeded in running a line to the jetty in order to rescue the vessel's four crewmen. The *Golden West* was transporting a cargo of general merchandise that included 12 barrels of oil. Most of the cargo was successfully salvaged, but the pounding waves soon caused the ship to break up. Owned by William and Fay Crone, the *Golden West* was built at St. Helens, Oregon, in 1923. The vessel was 72 gross tons. (Above, CHMM 009-16.1088; below, CHMM 007-25.206.)

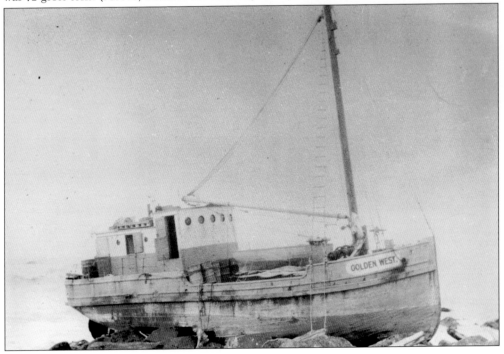

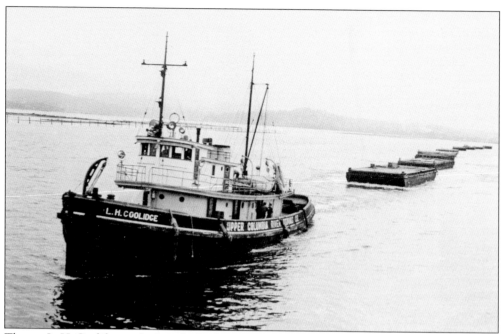

The tug *L. H. Coolidge* was built at the Barbee Marine Yards at Seattle, Washington, in 1943. It was originally built for the U.S. Army and named the *LT-140*. The 282–gross ton tugboat was owned by the Upper Columbia River Towing Company at the time of its loss. (CHMM 009-16.1083.)

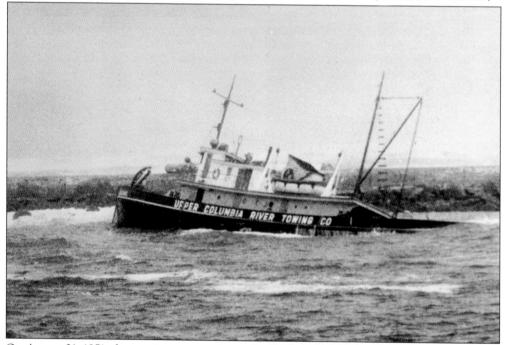

On August 21, 1951, the steering gear on the tug *L. H. Coolidge* failed while it was towing a barge out of the Coquille River. The tugboat intended to transport the cargo of logs to Astoria, but an equipment failure caused it to strand on the north jetty. In the above photograph, the damaged vessel is taking on water and leaning to one side. (CHMM 007-25.199.)

Fortunately a second tugboat, the *Quinett*, was in the area. Through its intervention, the cargo-laden barge was rescued and towed back up the Coquille River. The entire crew of the tug *L. H. Coolidge* reached shore safely. Salvage operations lasted several months. In the photograph on the right, the sunken vessel is being raised out of the water. (CHMM 009-16.957.)

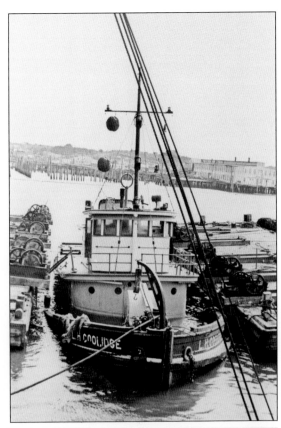

By October, the *L. H. Coolidge* had been raised and temporarily patched. The salvage vessel, aptly named the *Salvage Chief*, towed the *L. H. Coolidge* away from the Coquille River with the intention of delivering it to Portland for permanent repairs. Disaster struck the battered tug a second time when it sank off the coast of Yachats, Oregon, on October 29. This time it became a total loss. (CHMM 995-1.14972.1.)

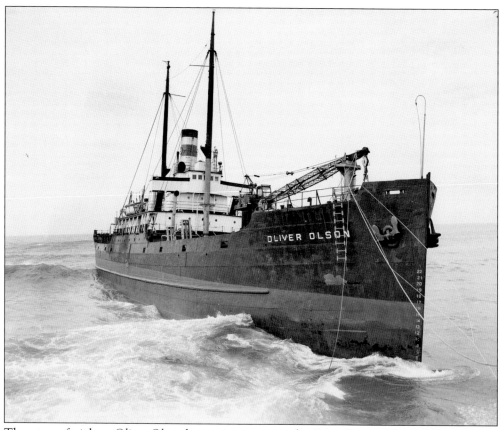

The steam freighter *Oliver Olson* began its career as the *Point Bonita*. The 2,225–gross ton vessel was built by the Albina Engine and Machine Works at Portland in 1918. The lumber carrier was also named the *San Pedro* before it was purchased by Oliver J. Olson and Company. (CHMM 009-16.368.)

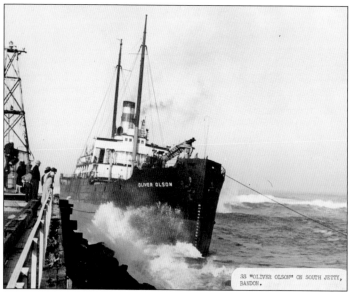

The packaged lumber carrier *Oliver Olson* was thrown off course by a strong current and 40-mile-per-hour winds while entering the Coquille River on November 3, 1953. Capt. Carl Hubner was unable to correct the ship's course before the vessel grounded on the outer edge of the south jetty. In this photograph, a crowd has gathered to see the stranded boat. (CHMM 003-7.18.)

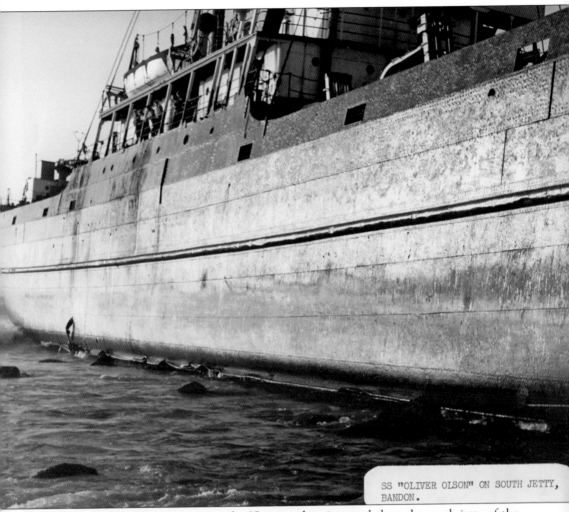

SS "OLIVER OLSON" ON SOUTH JETTY, BANDON.

The *Oliver Olson* had been in service for 35 years when it stranded on the south jetty of the Coquille River in November 1953. On the following day, all 29 members of the lumber ship's crew were safely brought ashore using a breeches buoy device. Initially, recovery efforts were optimistic. After all, the *Oliver Olson*'s sister ship, the *Cynthia Olson*, grounded near the same location the previous year and was successfully salvaged. Unfortunately, it did not take long to realize that the *Oliver Olson* had sustained serious damage to the bottom of its hull. Three gaping holes had been torn in the ship's steel plates on the starboard side. There were fears that if any attempts were made to move the *Oliver Olson* the ship would fill with water and capsize. If this happened, the boat might block the harbor entrance and prevent other ships from entering or leaving the port. (CHMM 003-7.19.)

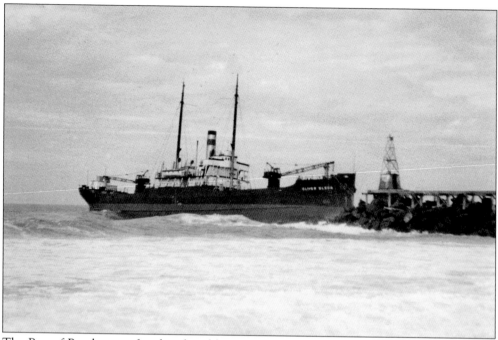

The Port of Bandon was faced with a dilemma. The steam freighter *Oliver Olson*, which was insured for $250,000, had been declared a total loss. But attempting to remove the damaged ship from the jetty could cause additional problems. Then came a brainstorm. The port was in need of an improved jetty, and the shipwreck was perfectly aligned with the existing one. The ship's valuable gear was salvaged and the top portion of the *Oliver Olson*'s hull removed with cutting torches. The remaining bottom portion of the hull was then filled with rocks and became part of a 450-foot extension of the south jetty, a project that was completed in the summer of 1954. (Above, CHMM 007-25.210; below, CHMM 009-16.400.)

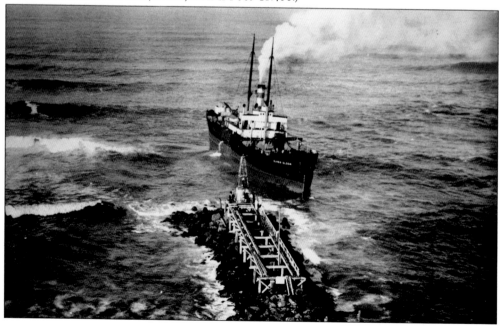

Seven

COASTAL WRECKS

The Oregon coast is treacherous and difficult to navigate. There are many obstacles for mariners to overcome or, preferably, avoid. These include sand shoals, hidden reefs, and submerged rocks. Part of the beauty of the rugged coastline is the "sea stacks" that are located a short distance from shore. They are the remnants of land that have eroded from the constant wave action until all that remains is tall pieces of rock. From land, they are beautiful, but they can be perilous for ships at sea.

The weather can be another major problem for mariners whose vision can be impaired by heavy fog, which can lead to collisions and groundings. There are seasonal problems for ships to overcome as well. For instance, summers on the coast are extremely windy, and winter storms can include gale-force winds and heavy currents. In addition, the area is known for its "sneaker waves," which are excessively large coastal swells that can appear without warning. These waves can damage, disable, or even capsize vessels. The combination of these challenges has led to hundreds of shipwrecks along the coastline.

This chapter discusses shipwrecks that occurred along the coast of Coos County; however, it excludes the wrecks that occurred on the North Spit, which has been the location of enough maritime accidents to merit its own chapter (chapter two).

Numerous changes have been made to improve maritime safety along the Coos County coastline. Two lighthouses, the Coquille River and the Cape Arago, were constructed near the mouths of the two main bodies of water, the Coos and Coquille Rivers. Jetties were also constructed at the mouths of both rivers to improve their safety and maintain a reliable channel depth. Construction of the jetties had a large impact on both rivers. The mouth of the Coquille River was forced to stay in the same location. Prior to the construction of Coos Bay's south jetty, the area that is now known as Bastendorff Beach was under water. Coos Head, which had historically been a frequent shipwreck location, is now located inside the mouth of the river.

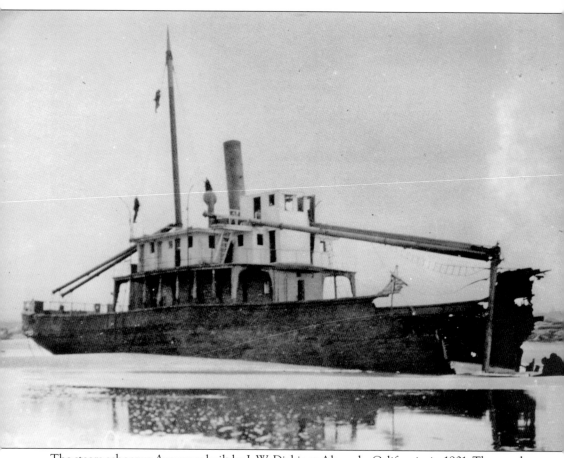

The steam schooner *Acme* was built by J. W. Dickie at Alameda, California, in 1901. The wooden-hulled vessel was 416 gross tons. The *Acme* arrived at the Coquille River bar on the night of October 30, 1924. There was a storm brewing that made the bar too rough to cross, so Capt. Fred Miller decided to wait for calmer conditions. Around 2:00 a.m., he turned control of the vessel over to his first mate and went to bed. Two hours later, Miller woke to discover his ship caught in the breakers. The captain attempted to bring the ship about and head out to open sea, but it would not turn. He knew that if they stayed where they were, the rough waves would continue to pound against the ship's wooden hull until it broke apart. Therefore, Miller intentionally ran the schooner aground in order to save the lives of his crew. (CHMM 007-25.211.)

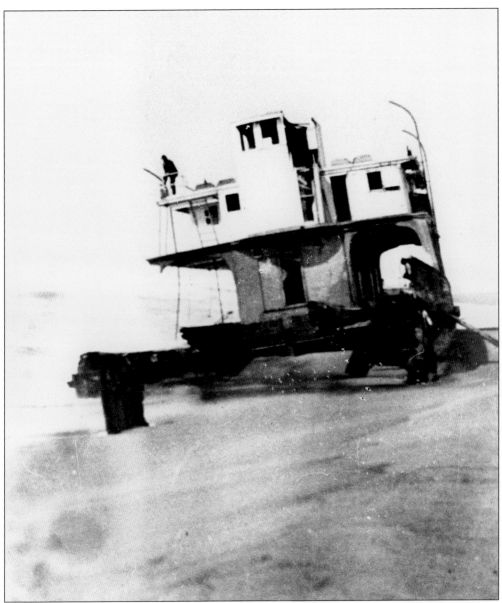

On October 31, 1924, the schooner *Acme* grounded approximately 4 miles north of the Coquille River bar (near Cut Creek). Although their lifeboat capsized in the rough surf, five crewmen made it safely to shore. The men were in the process of setting up a breeches buoy line to the ship when the Coast Guard arrived. Together, they assisted the remaining 10 crewmen to shore. The Moore Mill and Lumber Company purchased the *Acme* wreck from its underwriters in order to salvage the cargo of 100 tons of railroad iron. Most records agree that the wooden-hulled ship eventually broke up due to winter storms. However, one report claimed that it was a fire that caused the wreck to break apart. The two pieces were eventually buried in the sand but at different locations. The stern section ended up on the beach near the Coquille River lighthouse while the bow section remained near the original grounding site. This portion occasionally reappears after a good winter storm, when the combination of strong winds and heavy currents uncovers the wreck. (CHMM 009-16.356a.)

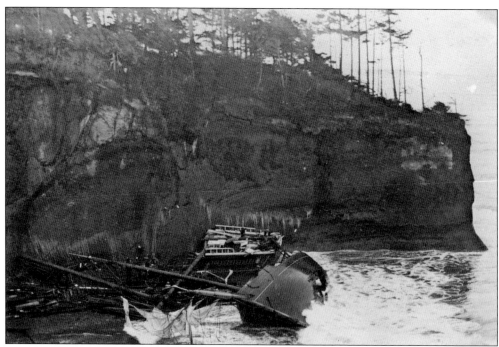

The three-masted schooner *Advent* was built by K. V. Kruse at North Bend, Oregon, in 1901. The 431–gross ton ship was owned by Capt. Asa Meade Simpson and used to transport timber for the Simpson Lumber Company. As a sailing vessel, the *Advent* was forced to rely on the wind to transport it safely from port to port. Unfortunately, the wind abated while the ship was sailing into the Coos Bay on February 18, 1913. These photographs show the *Advent* after it drifted ashore near Coos Head and began to break apart. Above, the bow is still relatively intact. However, as the photograph below demonstrates, the constant barrage of waves soon tore the entire hull of the ship apart. (Above, CHMM 007-25.528; below, CHMM 008-45.46.)

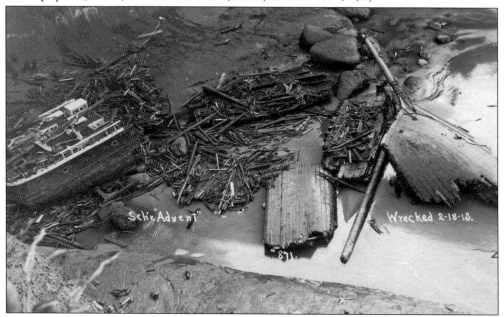

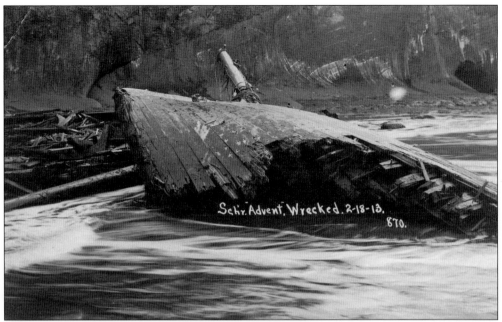

On February 18, 1913, the wind died while the schooner *Advent* was attempting to enter the Coos Bay. As the ship began to drift toward the south spit, Capt. B. W. Mont Eton ordered his crew to drop all of their anchors approximately 600 yards from shore. The men were rescued by the U.S. Life-Saving crew. The shattered remains of the wooden-hulled *Advent* were scattered at the base of the rocky cliffs south of the Coos Bay bar. The ship became a total loss. Below, several people pose for a photograph while exploring the stern of the wrecked ship. One man has his hand on the ship's wheel, which has been torn from its post. Another man sits on the remains of one of the ship's three masts, which are lying across the deck. (Above, CHMM 999-2.6; below, CHMM 992-8-2699.)

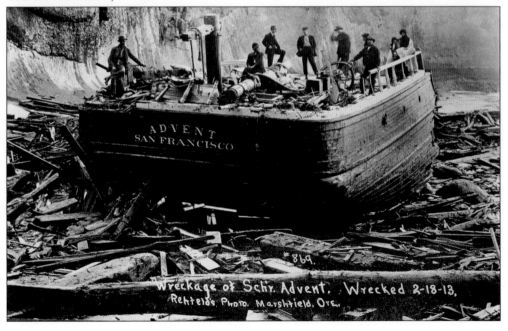

The British bark *Baroda* was built at Dunbarton, Scotland, in 1891. The 1417-ton ship wrecked on at least two different occasions, but it was salvaged, repaired, and returned to service after each incident. On the first occasion, the *Baroda* stranded south of Bandon in 1901. The second time, it sank at Esquimalt, British Columbia, in 1910. (CHMM 007-25.514.)

On August 28, 1901, the *Baroda* encountered thick fog while sailing along the Pacific coastline. It was on its way from Callao, Peru, to Portland, Oregon, to pick up a cargo of flour when it stranded near the mouth of Fourmile Creek (south of Bandon). The crew reached shore safely using lifeboats from the ship. (CHMM 009-16.1070.)

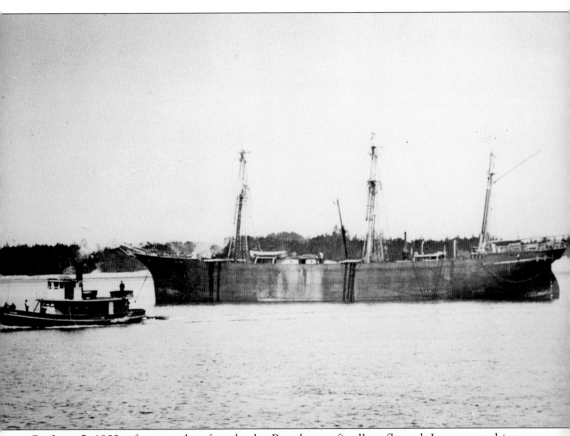

On June 5, 1902, after months of work, the *Baroda* was finally refloated. It was towed into Coos Bay for repairs. In the above photograph, the bark *Baroda* is anchored on the Coos Bay. It was later converted into a barge and used to transport cargo in British Columbia, Canada. (CHMM 009-16.385.)

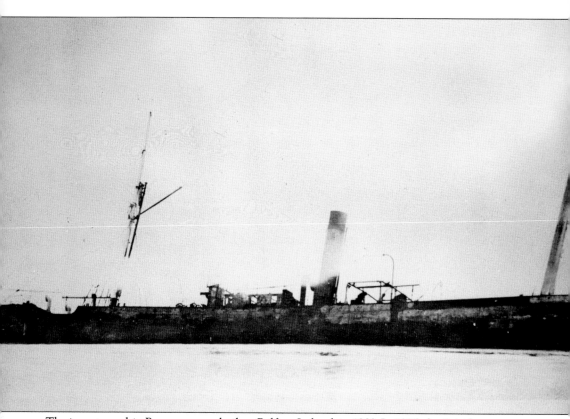

The iron steamship *Bawnmore* was built at Belfast, Ireland, in 1889. In 1895, the British steamer was traveling with a cargo that included lumber, building materials, coke lime, machinery, streetcars, purebred cattle, and passengers. On August 28, the *Bawnmore* stranded several miles south of the Coquille River (near Floras Lake) in a dense fog. The wreck was blamed on a faulty compass. All of the passengers and crew reached shore safely. Although the 1,430-ton *Bawnmore* became a total loss, a large amount of its cargo was salvaged before the interior of the vessel caught on fire. The *Bawnmore* later became the stuff of legends. The first story claimed that some of the cattle were rescued and bred with cattle in northern Curry County in order to start what was known as the "Bawnmore Breed." The second story claimed that some of the streetcars were brought ashore, and that they were the only streetcars that the county ever had. (CHMM 009-16.329.)

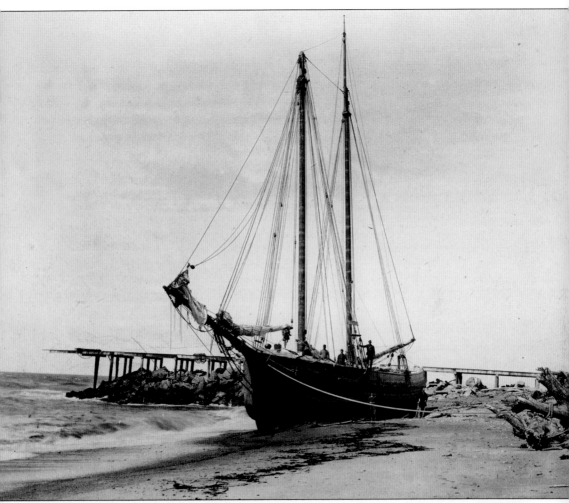

The scow schooner *Berwick* was built by Matthew Turner at Benicia, California, in 1887. The vessel was 100 gross tons. The ship had a history of maritime mishaps, but it usually managed to avoid major damage. On April 12, 1896, the *Berwick* attempted to cross the Coquille River bar and was struck by a large wave that caused it to broach. A second wave struck the vessel before Captain Straham or his crew had time to correct its position. The *Berwick* was forced onto the beach on the south spit of the Coquille River. Although Capt. Hans Reed received a contract to refloat the *Berwick*, it took him several months to complete the job. By the middle of December 1896, the schooner was finally repaired and ready to return to service. (CHMM 988-P432.)

Although the *Berwick* had a history of maritime accidents, only one of its shipwrecks occurred within the boundaries of Coos County. However, the ship did visit the port after a mishap in February 1908. Kruse and Banks shipyard repaired the ship's damaged rudder, and the *Berwick* departed the Coos Bay on March 12. The following day, the *Berwick* arrived off the coast of the Siuslaw River. It attempted to enter the river without the aid of a tugboat but only succeeded in running into the beach south of the river mouth. The breakers turned the ship sideways before pushing it northward. The battered ship came to rest on the north spit where it was high and dry at low tide. It became a total loss. Although the *Berwick* was originally built as a sailing vessel, it had two 50-horsepower standard gas engines installed a few years before its final shipwreck. Other upgrades made it one of the first cold storage vessels in operation on the Pacific coast. (CHMM 009-16.1474.)

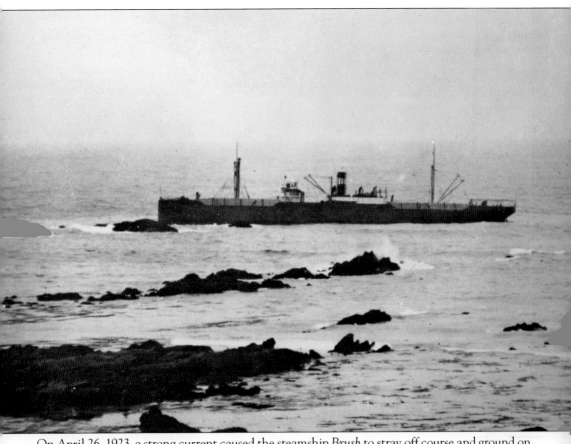

On April 26, 1923, a strong current caused the steamship *Brush* to stray off course and ground on Simpson Reef, which is located a few miles south of the entrance to the Coos Bay. Fog was also a contributing factor in the wreck. The steel-hulled steamer was owned by the North Atlantic and Western Steamship Company of Boston, Massachusetts. The *Brush* was built by the American International Shipbuilding Corporation at Hog Island, Pennsylvania, in 1920. It was 5,543 gross tons. The *Brush* came to rest on the reef amidships with a large section of the bottom of its hull torn open. The engine room immediately flooded, and the hull soon cracked. All 34 crewmen and one passenger, the wife of the captain, were safely evacuated from the floundering ship by the U.S. Coast Guard. (CHMM 992-8-2735.)

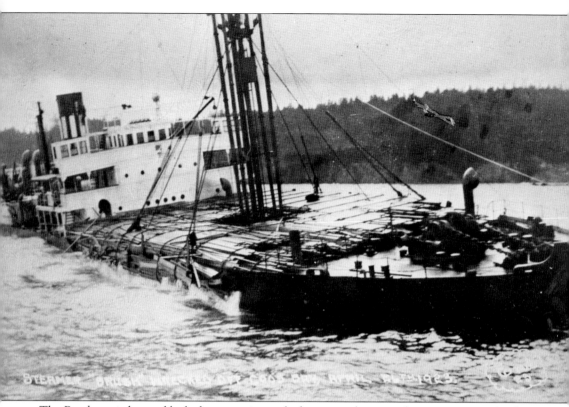

The *Brush* carried a good luck charm, an ivory elephant in a glass case that was given to the ship by its namesake when the vessel was launched. Unfortunately, the charm could not save the ship once it grounded on Simpson Reef around 4:00 a.m. on April 26, 1923. The *Brush* was traveling from Seattle to San Francisco (via Grays Harbor) with a cargo of lumber and general merchandise. It also carried some valuable bonded goods from the Orient, including silks. Part of the ship's cargo was salvaged before the ship broke up. Louis Simpson used some of the lumber to rebuild his Shore Acres mansion after the first was destroyed by a fire. (CHMM 992-8-2732.)

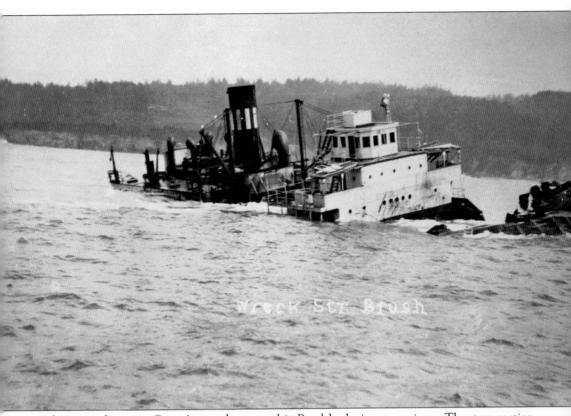

After grounding near Cape Arago, the steamship *Brush* broke into two pieces. The stern section soon slipped off the reef and into deeper water. In this photograph, the bow is still resting on a pinnacle of the reef, but before long it too slid below the surface. While investigating the accident, it was determined that the *Brush* was 15 miles outside of the usual course taken by vessels traveling south along the coastline. The U. S. Steamboat Inspectors found both Capt. George S. Mitchell and Second Mate C. A. Perkins guilty of negligence of their duties. Both of their licenses were suspended. At the time of the wreck, Perkins was at the wheel. He pleaded guilty, but claimed that he had sighted ships closer to shore prior to the wreck. (CHMM 992-8-2736.)

On August 30, 1966, the small fishing vessel *Cape Cross* struck Kitten's Rock near the mouth of the Coquille River. The boat's one-man crew was rescued from the rock by the Coast Guard. The *Cape Cross* drifted ashore near the Coquille River's south jetty where the continual pounding of the waves caused the vessel to break apart. The above photograph shows the small boat shortly after it drifted onto the beach south of the Coquille River's south jetty. The photograph below demonstrates what was left of the *Cape Cross* after the waves finished beating upon it. (Above, CHMM 009-16.1050; below, CHMM 009-16.1137.)

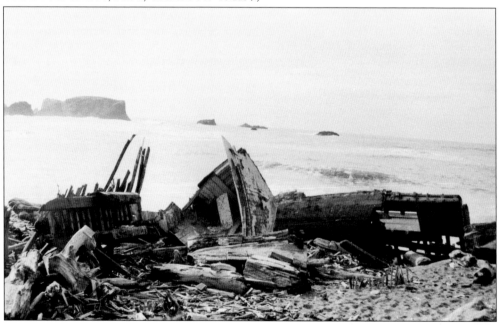

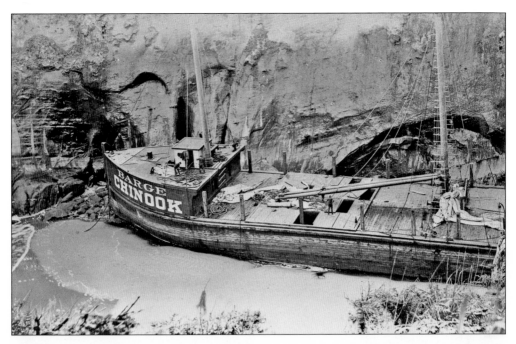

On April 12, 1907, the barge *Chinook* was the source of great anxiety for the residents of the Coos Bay area. The towline broke while the tugboat *Columbia* was towing the barge across the bar. The *Chinook* was carrying 4,000 pounds of dynamite. The barge drifted into the breakers before coming to rest against a rock bluff. Many feared that the dynamite would explode. Within a few days, the majority of the *Chinook*'s cargo had been safely salvaged. The barge became a total loss. Ironically, the cargo was intended for Bandon, but the Coquille River bar was too rough to cross. After towing the barge from San Francisco, the tugboat *Wizard* had turned the vessel over to the *Columbia* so it could be taken to Coos Bay to wait for calmer conditions. (Above, CHMM 009-16.332; below, CHMM 992-8-2739.)

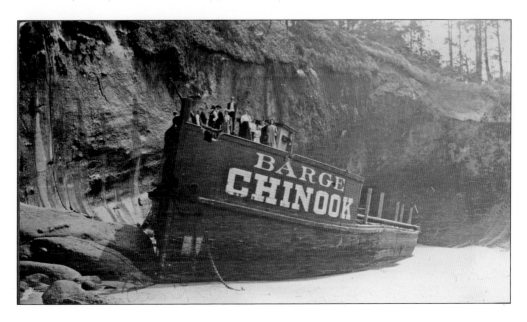

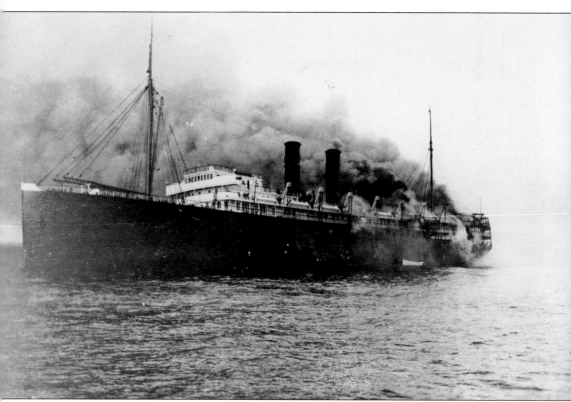

The steamship *Congress* had a very colorful history. The steel-hulled passenger liner was built at Camden, New Jersey, in 1913. The 7,985–gross ton vessel was owned by the Pacific Coast Steamship Company and valued at nearly $2 million. On September 13, 1916, a fire started in the passenger steamer's after hold but spread quickly. The *Congress* was on its way from San Francisco, California, to Seattle, Washington. Capt. N. E. Cousins ordered his crew to continue fighting the raging fire while the ship raced to the nearest port. Upon their arrival off the coast of Coos Bay on September 14, the captain ordered his crew to drop their anchors near the Cape Arago Lighthouse. In this photograph, smoke billows out of the ship as a small white lifeboat is being lowered to safety. (CHMM 966-83.25)

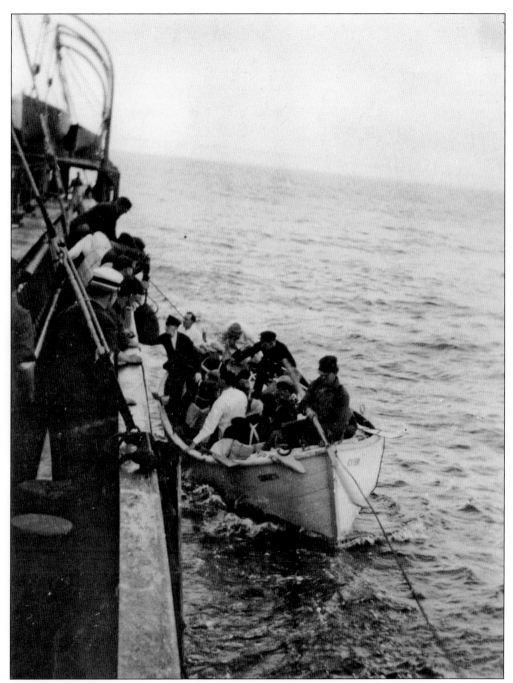

The passengers on board the coastwise passenger liner *Congress* remained calm when their captain gave the order to abandon ship. It was reported that they "took to the lifeboats in an orderly fashion." The fire that had begun in one of the cargo holds was continuing to consume the ship. Fortunately, all 253 passengers and 175 crewmen were safely evacuated. The seas were calm on September 14, 1916, which made it much easier for the crews of the U. S. Army Engineers dredge *Col. P. S. Michie* and the gas schooner *Tillamook* to retrieve the passengers and crew from the lifeboats and take them safely aboard their vessels. (CHMM 007-25.34.)

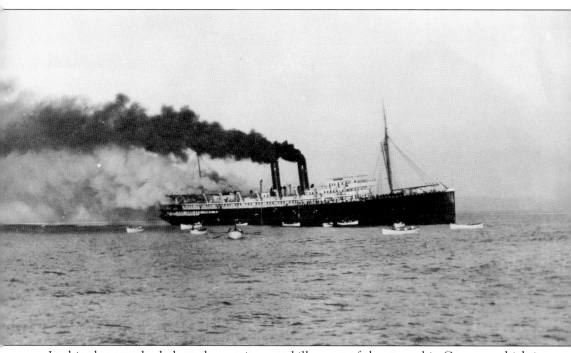

In this photograph, dark smoke continues to billow out of the steamship *Congress*, which is surrounded by little white lifeboats. One witness described them as goslings swimming around their wounded mother. All of the passengers of the steamship were safely evacuated, but the ship continued to burn for several days. Some reports claim that the fire burned so hot that it blistered the paint on the ships that attempted to approach it. The crew of the steam schooner *A. M. Simpson* spent 63 hours pumping water into the burning vessel in order to extinguish the fire. As the ship cooled, the *Congress* began to list (or lean), but it did not sink. (CHMM 982-190.55.)

Although the *Congress* is still smoldering, several men have boarded the vessel in order to survey the damage after the fire burned down. They can be seen standing at the railing on the right. Most of the paint has been burned off the hull of the ship. The photograph below reveals the extensive damage to the *Congress*. The fire essentially consumed everything above the waterline except for the ship's steel hull and superstructure. Nearly everything on the ship that was not made out of metal burned. It is interesting to compare this image to the ones on the previous pages. In doing so, it is easy to see how much of the ship, its decks, and railings have been consumed by the fire. (Right, CHMM 972-100h; below, CHMM 992-8-3269.)

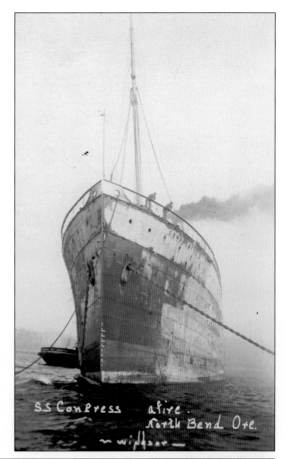

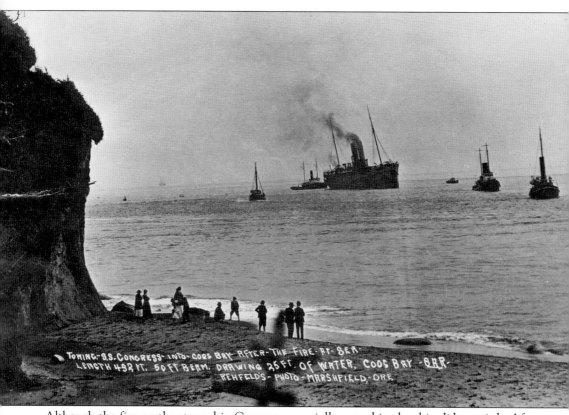

Although the fire on the steamship *Congress* essentially gutted it, the ship did not sink. After a few days, several boats retrieved the ship and towed it to a dock on the Coos Bay. Several onlookers gathered to watch the spectacle from the shore. The *Congress* was then towed to Seattle, Washington, where the hull was salvaged and rebuilt at a cost of $2 million. Amazingly the *Congress* remained in service for many more years. It was sold to new owners and renamed the *Nanking*. They put the ship to work carrying cargo to the Orient where there were rumors that it transported opium and slaves. The company went out of business, and the ship was sold back to its former owners, who renamed it the *Emma Alexander*. During World War II, the ship was renamed the *Empire Woodlarks* and used to transport British troops. After the war, it was intentionally sunk at sea while carrying a cargo of surplus bombs. (CHMM 961-33.33.)

On March 22, 1962, the sea was rough, and there were reports of 30- to 40-foot breakers just off the coast of the Coos Bay. A large wave struck the stern of the pilot boat Cygnet while it was attempting to cross the Coos Bay bar. The boat capsized, and the captain and deckhand were swept overboard. It was reported that Captain Hampel was not wearing a life jacket when the accident occurred. He was last seen swimming on his back in the churning surf. It is presumed that he drowned, but his body was never recovered. His deckhand was much more fortunate. The U.S. Coast Guard arrived on the scene and rescued him approximately 20 minutes after the accident occurred. In this photograph, the boat has returned to an upright position but is still listing to the side while the waves continue to pound against it. (CHMM 009-16.271.)

Tragically, the captain of the Coos Bay pilot boat *Cygnet* drowned when the vessel capsized off the coast of the Coos Bay on March 22, 1962. The *Cygnet* drifted ashore on the North Spit. The above photograph depicts the boat on its side in the waves at high tide. The image below was taken much later. A close look reveals a wooden contraption beneath the boat. It is believed that it was built during low tide in order to keep the boat in an upright position. When the tide came back in, the boat was refloated and towed back onto the Coos Bay. The *Cygnet* was repaired and returned to service. (Above, CHMM 008-73.1; below, CHMM 992-8-2777.)

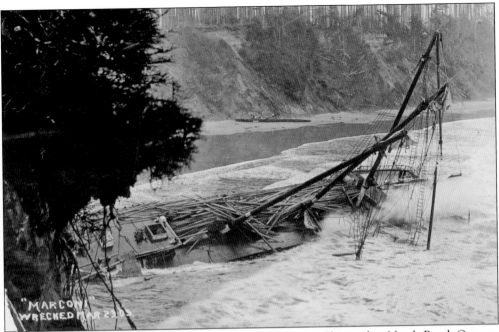

The four-masted schooner *Marconi* was built at the Simpson Shipyard in North Bend, Oregon, in 1902. The wooden-hulled vessel was 693 gross tons. The *Marconi* was the last ship built for Capt. Asa Simpson at his North Bend shipyard. (CHMM 959-89e.)

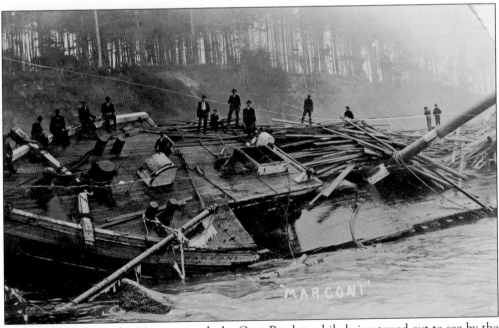

On March 23, 1909, the *Marconi* struck the Coos Bay bar while being towed out to sea by the tugboat *Columbia*. It was carrying a full load of lumber destined for Valparaiso, Chile. The line connecting the two vessels broke, and the *Marconi* began to drift south. The ship had no sails set at the time, which made it helpless in the waves. (CHMM 972-100p.)

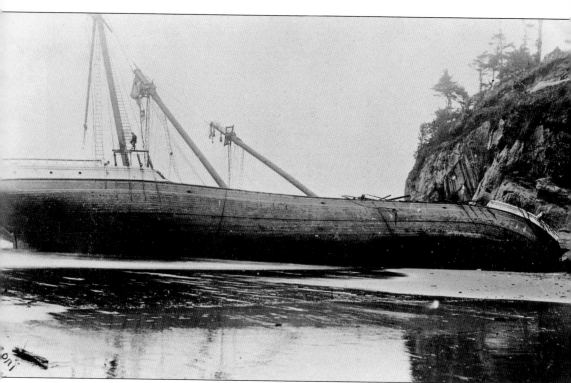

The *Marconi* stranded 300 yards from a high bluff on the south spit of the Coos Bay on March 23, 1909. Four years later, the *Santa Clara* came to rest in the same location. After grounding, two lines were floated ashore from the disabled vessel and retrieved by people standing on the rock bluff. They used the lines to rig a breeches buoy device to rescue two members of the crew. The U.S. Life-Saving crew arrived later and assisted the remaining eight crewmen safely to shore. They were forced to travel overland to the wreck site due to the rough surf. In this photograph, the ship rests on its side on the beach at low tide. Its hull is still intact, but several of the masts have already fallen. There is a man climbing the rigging on the left side of the photograph. (CHMM 007-25.341.)

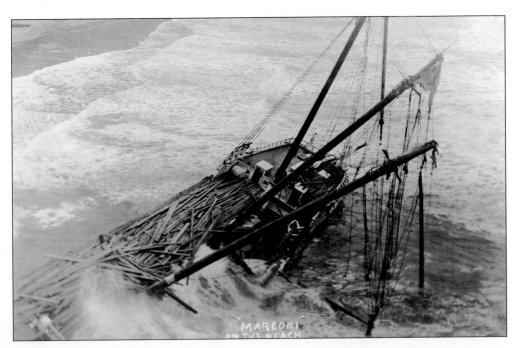

The steamship *Marconi* eventually broke up in the rough surf south of the Coos Bay bar. No lives were lost in the accident, but the $30,000 ship and its $10,000 worth of cargo were completely destroyed. The schooner *Marconi* was owned by the Simpson Lumber Company, and neither the ship nor its cargo was insured. In the above photograph, the stern of the vessel is awash with waves. The boat is listing to one side while the lumber cargo has come loose, and the masts are beginning to fall into the sea. Below, a group of men explore the bow section after the vessel broke apart. (Above, CHMM 982-190.66; below, CHMM 007-25.342.)

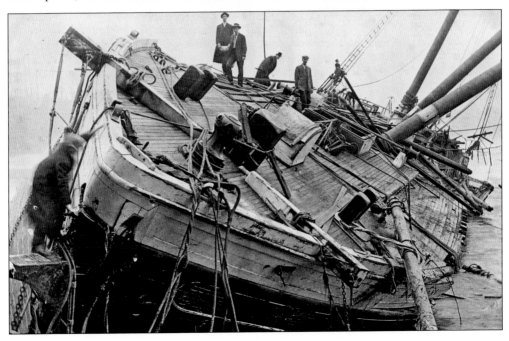

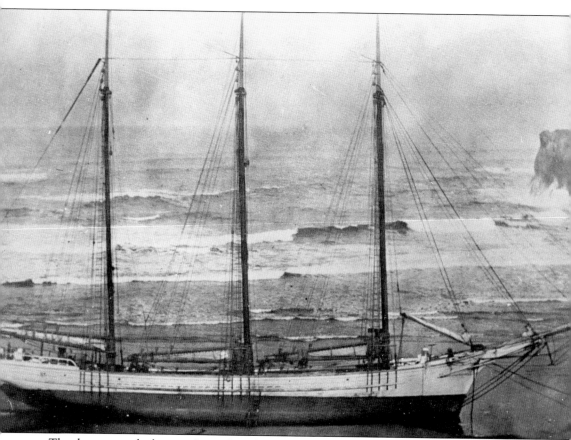

The three-masted schooner *Onward* was built by S. Danielson at Parkersburg, which is located on the Coquille River, in 1901. The 276–gross ton vessel was used to haul lumber from the Parkersburg Mill to San Francisco, California. There are two versions of the story of how the *Onward* wrecked on February 25, 1905. The first version is fairly simple. It claims that the wind died while the schooner *Onward* was attempting to cross over the Coquille River bar. The sail-powered vessel was left completely helpless. The ship drifted south, strayed too close to shore, and grounded on the beach. (CHMM 009-16.289a.)

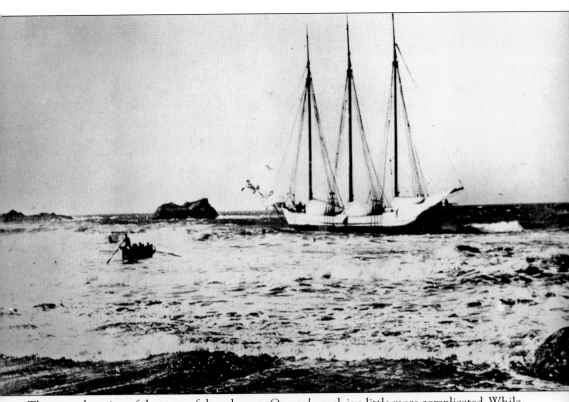

The second version of the story of the schooner *Onward* wreck is a little more complicated. While returning on February 25, 1905, the *Onward* encountered two other schooners, the *Advance* and the *Hugh Hogan*, which were waiting off the coast to enter the Coquille River. The bar was too rough for towing that day, so the ships were without the aid of a tugboat to help them across. Rather than waiting for calmer conditions, the *Advance* decided to try its luck. It sailed across the bar with no difficulty. Heartened by this success, Captain Anderson ordered the crew of the *Onward* to follow suit. Unfortunately, midway across, one of the center boards (a retractable piece of the ship) dropped and struck the bottom of the river. The vessel came to an abrupt stop and then broached. To make matters worse, some of its sails became damaged. The crew attempted to correct the ship's position, but the wind pushed it south. The *Onward* grounded on the beach just north of Lookout Point where all eight of its crewmen made it safely to shore. (CHMM 009-16.289.)

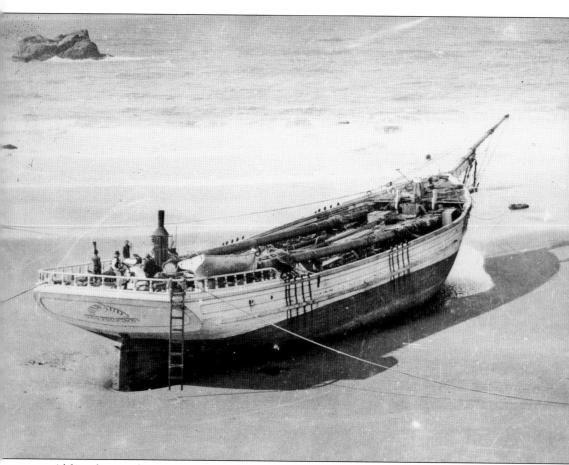

Although several attempts were made to refloat the schooner *Onward*, it was eventually declared a total loss and abandoned. Shipbuilder Emil Heuckendorff bought the shipwrecked hull, but the southern Oregon coast was struck by a storm before the ship could be salvaged. There was some concern that the large waves might pull the disabled vessel out to sea, so an iron ring was attached to a large rock on the beach. A line was secured between the ring and the ship to ensure that it remained in the same location. After the storm passed, Heuckendorff salvaged the masts and riggings and used them in the construction of the schooner *Oregon*. In the above photograph, there are men working on the deck of the *Onward*. Its three masts have already been taken down and are lying across the deck. (CHMM 992-8-1651.)

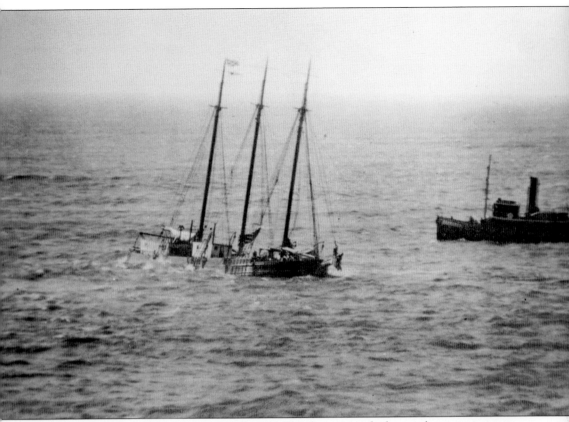

The story of the *Ozmo* is one that comes full circle. The three-masted schooner began its career on the Coos Bay and returned there to end it. The *Ozmo* was built by K. V. Kruse at his Marshfield (now the city of Coos Bay) shipyard in 1904. The wooden-hulled vessel was originally called the *Hugh Hogan*. At 765 gross tons, it was converted to an auxiliary schooner and renamed the *Ozmo* late in its career. On May 17, 1922, the *Ozmo* struck Orford Reef near Cape Blanco and began to take on water. It was traveling from San Francisco, California, to Bethel, Alaska, with a cargo of general merchandise at the time of the accident, which was blamed on fog and strong currents. The steam schooner *Daisy* arrived the following day and took the *Ozmo*'s crew and one passenger, the chief engineer's wife, on board. (CHMM 007-25.40.)

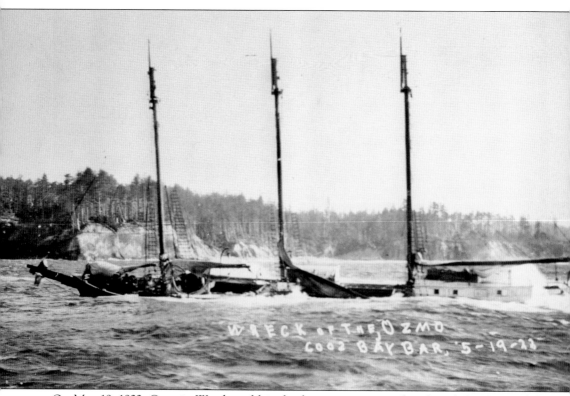

On May 19, 1922, Captain Worth and his chief engineer remained on board the *Ozmo* while the *Daisy* attempted to tow the disabled ship across the Coos Bay bar. Unfortunately, the steam schooner was unable to control the waterlogged vessel, which got caught in a strong current and drifted onto the south spit. The two men on board the *Ozmo* were rescued by the Coast Guard. On May 22, 1922, the tide refloated the beached auxiliary schooner *Ozmo*, and it drifted toward the Coos Bay. The gas boat *Zebra* helped the tug *Fearless* to get a line aboard the disabled vessel and tow it across the Coos Bay bar and up the bay. The *Ozmo* was later found to be damaged beyond repair. Here the *Ozmo* is aground on the south spit of the Coos Bay. (CHMM 009-16.349.)

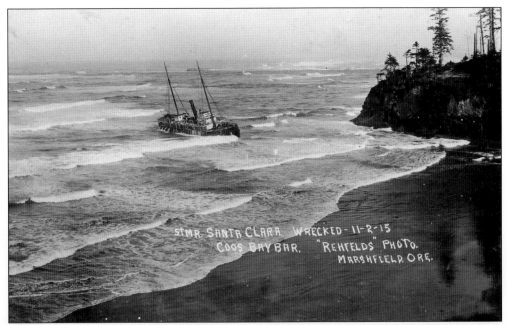

The wreck of the steam schooner *Santa Clara* is one of the most tragic in Coos County history. The ship was built at Everett, Washington, as the *John S. Kimball* in 1900. The 1,588–gross ton vessel was the largest steam schooner in operation on the West Coast at the time of its launch. It was also briefly named the *James Dollar*. (CHMM 961-33.15.)

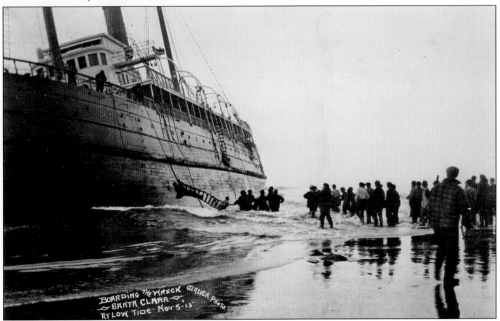

On November 2, 1915, the steamer *Santa Clara* struck an uncharted reef or sand bar south of the entrance to the Coos Bay. It eventually broke loose, spun three times, and then drifted toward shore. The vessel was filling with water and starting to break up, so Capt. August Lofstedt ordered the lifeboats to be lowered into the rough surf. Two of the boats capsized and drowned their occupants. (CHMM 992-8-2851.)

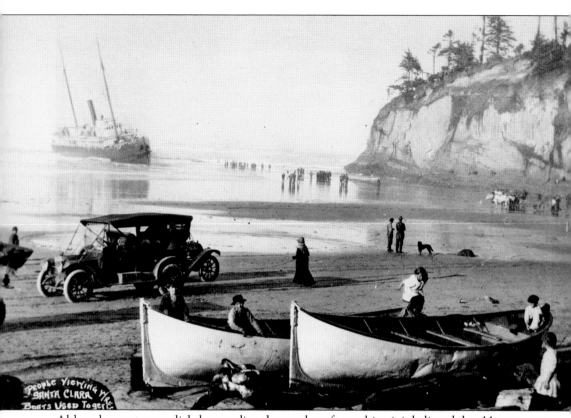

Although reports vary slightly regarding the number of casualties, it is believed that 14 passengers and crewmen from the steamship *Santa Clara* drowned when their lifeboats capsized near the south spit of the Coos Bay in November 1915. Ironically, most of the people that survived the shipwreck chose to remain on the sinking ship until the rough surf calmed down rather than attempting to take a lifeboat to shore. A Coast Guard crew assisted in the rescue of the remaining passengers and crew. At low tide, the shipwreck was high and dry on the beach. In this photograph, the *Santa Clara* is visible in the background. A large crowd of people has gathered to view the wreck or offer assistance. Two damaged lifeboats are visible in the forefront. The danger has passed, and there are now children playing in them. (CHMM 009-16.343a.)

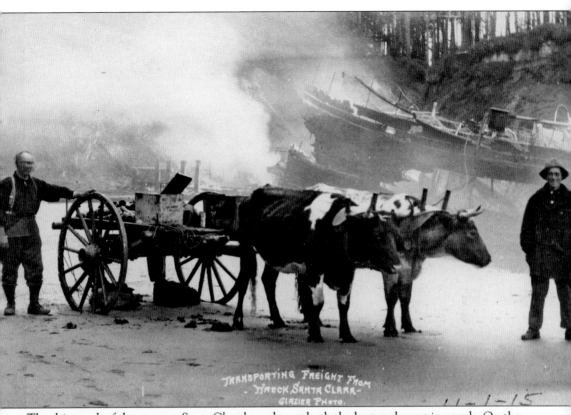

The shipwreck of the steamer *Santa Clara* brought out both the best and worst in people. On the one hand, many people came to offer assistance. Several local doctors, including Everett Mingus and Ira Bartle, tended the injured. Pauline Wasson, manager of the Sunset Inn at nearby Sunset Bay, served coffee and food to the rescuers. Several people loaned their cars to transport the survivors to town. On the other hand, a large number of people looted the shipwreck. One report claimed that hundreds of people were involved and that someone even attempted to dynamite the bow of the ship in order to make the "booty" more accessible. Much of the cargo that was not stolen became tainted by leaking oil and water. Less than a week after the *Santa Clara* grounded, arsonists set the wooden hull on fire. The heat caused one of the ship's oil tanks to explode. The fire destroyed nearly everything above the waterline. The wreck continues to smolder in the background of this photograph while two men pose next to a wagon full of salvaged items. (CHMM 982-190.56.)

There were several investigations into the wreck of the steamer *Santa Clara*. Capt. August "Gus" Lofstedt was taken to trial for negligence in December 1915. It was discovered that the ship's steering gear was not working properly prior to the wreck. The captain pled guilty and lost his license. A federal officer was sent from Portland, Oregon, to investigate the pilfering of 20 sacks of mail. The engines and boilers from the shipwreck of the *Santa Clara* are shown here. The engine is on the left, and the boilers are in center of the photograph. (CHMM 982-190.57.)

Several of the items recovered from the wreck of the steamer *Santa Clara* were later donated to the local historical society, which runs the Coos Historical and Maritime Museum. Among these objects is the small sugar bowl shown above. It had been part of a table service on the ill-fated steamship. After the *Santa Clara* wrecked, a surviving crewman visited a beach cottage near the wreck site. The man offered the sugar bowl to the homeowner in exchange for lunch. Another famous object from the *Santa Clara* wreck was a whistle. It was salvaged by L. J. Simpson and used at his Old Town Mill in North Bend for several years. (CHMM 968-151.)

www.arcadiapublishing.com

MAP SEARCH

Discover books about the town where you grew up, the cities where your friends and families live, the town where your parents met, or even that retirement spot you've been dreaming about. Our Web site provides history lovers with exclusive deals, advanced notification about new titles, e-mail alerts of author events, and much more.

MADE IN THE USA

Arcadia Publishing, the leading local history publisher in the United States, is committed to making history accessible and meaningful through publishing books that celebrate and preserve the heritage of America's people and places. Consistent with our mission to preserve history on a local level, this book was printed in South Carolina on American-made paper and manufactured entirely in the United States.

This book carries the accredited Forest Stewardship Council (FSC) label and is printed on 100 percent FSC-certified paper. Products carrying the FSC label are independently certified to assure consumers that they come from forests that are managed to meet the social, economic, and ecological needs of present and future generations.

FSC
Mixed Sources
Product group from well-managed
forests and other controlled sources
Cert no. SW-COC-001530
www.fsc.org
© 1996 Forest Stewardship Council

Find Your Place in History.